The
Sketchbook

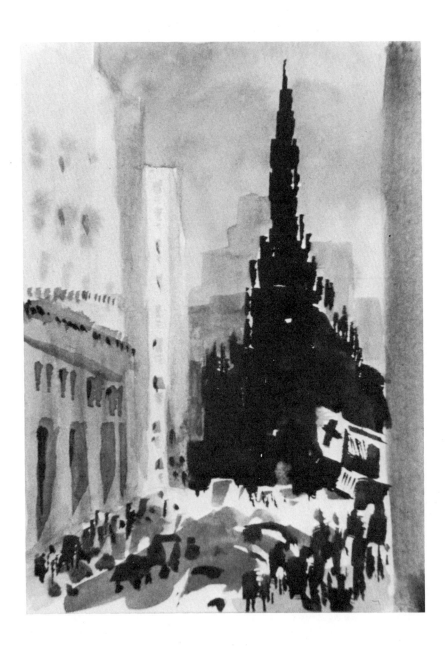

Dale Meyers, NA, AWS

The Sketchbook

VNR VAN NOSTRAND REINHOLD COMPANY
New York Cincinnati Toronto London Melbourne

Frontispiece: Watercolor sketch, $6^{1}/_{4}$ x$4^{1}/_{2}''$, of Trinity
Church from Wall Street, New York City, 1975.

Published by Van Nostrand Reinhold Company Inc.
135 West 50th Street
New York, New York 10020

Van Nostrand Reinhold Publishers
1410 Birchmount Road
Scarborough, Ontario M1P 2E7, Canada

Van Nostrand Reinhold Australia Pty. Ltd.
480 Latrobe Street
Melbourne, Victoria 3000, Australia

Van Nostrand Reinhold Company Limited
Molly Millars Lane
Wokingham, Berkshire RG11 2PY, England

16 15 14 13 12 11 10 9 8 7 6 5 4 3 2 1

Library of Congress Cataloging in Publication Data

Meyers, Dale.
 The sketchbook.

 1. Meyers, Dale. 2. Drawing—Technique. I. Title.
NC139.M45A4 1983 741.973 82-10870
ISBN 0-442-26272-8

To Mario—an artist in everything

Contents

Introduction 9

One Artist's Use of the Sketchbook 12

Materials 15

The Sketchbook as a Manual 19

Six Views and Other Sketches 21

The Sketchbook as a Sourcebook 46

How to Wait Without Waiting 62

The Sketchbook as a Log or Journal 71

In and Around Your Home 100

And Not So Close to Home 113

Index 127

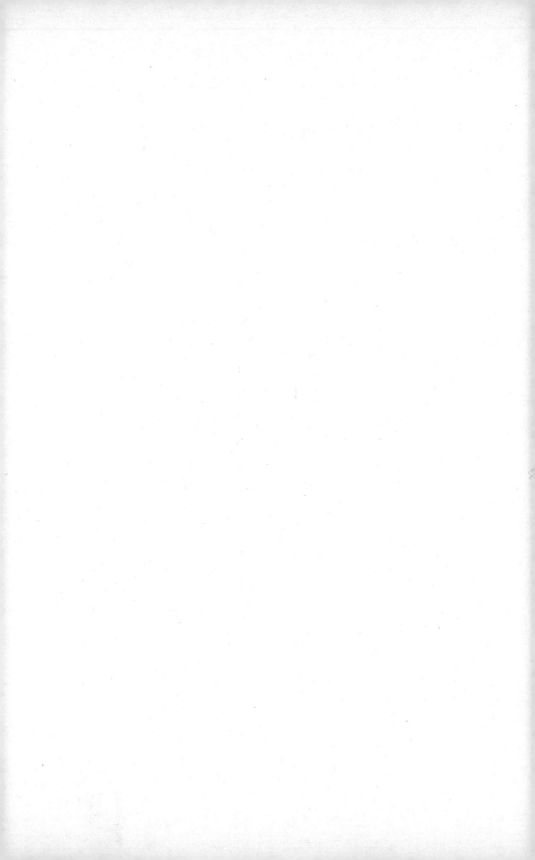

Introduction

The sketchbook should be a guiding force in your training as an artist. Working in one used to be my least favorite activity until I began to realize it was essential to my continued growth. It is not something that you do once and then stop: for the artist, it is a lifelong pursuit.

The sketchbook should become your art bible, containing not only recorded scenes but practice sketches, color schemes, names and addresses of fellow participants in workshops, quotes from the masters, and so on. And you will find it a handy reference because everything is "on file" in it for that particular period of time.

Many years ago, when I began concentrating in my favorite field (that of watercolor), I was fortunate enough to find as a guide a superb teacher and watercolorist, Mario Cooper. In our classes with him, students had the inspiration of hard work liberally laced with classical music, poetry, and philosophy. Each one of us contributed something in these areas, so along with demands upon our painting abilities we studied humanities and music appreciation as well as color and composition. My choice of teacher was a good one in many ways, for we later married.

It was during this time of learning and practice that our professor also taught us some Zen and "how to wait without waiting." My sketchbooks have become records, therefore, not necessarily of my waiting but of my travels as well as my life.

The pleasure of reliving a trip through your sketchbooks is more exciting than going through any collection of slides or photos. You do not forget areas you have painted. Most impressions overlook the details—you can refer to your slides or photographs for details—but the scene remains in your memory. Value

Watercolor sketch, $6^{1}/_{4}$ x$4^{1}/_{2}''$, of a rattan grove in Florida, 1975. Here I learned the difference between rattan and bamboo. Rattan, a climbing palm of the genus *Calamus,* bears razor-sharp spikes that grow from its joints, while bamboo, from a family of hollow, treelike grasses, does not. Don't ever try to walk through a rattan grove.

sketches and color notes, which retain a flavor of the moment that a snapshot can never catch, may be used later in the studio as guides to larger paintings.

Because of the great enjoyment these records have brought to me and to many of my friends and students, this book was born. Perhaps it will merit your enthusiasm as well, and you will use similar methods of recording your travels and important events in your life.

One Artist's Use of the Sketchbook

his is a picture book. It is filled with on-the-spot sketches I have made over a span of many years, some as lessons for students, some as exercises for myself, and some as recordings of sights and scenes or personal events I wanted to remember.

I would begin a new book each January, and as the years went by these books grew from sketching manuals to become journals, logs, albums, and sourcebooks. As I recorded sights I also began to record thoughts, sayings, names, and all sorts of things. During trips they held flight numbers, itineraries, lists of foreign words and phrases, and maps. Some notations include rubbings of messages laboriously carved by prisoners confined in the Venetian dungeon just across the Bridge of Sighs. And in Jerusalem, my book reminds me that if we go to the Leviathan Restaurant we must be sure to order the house salad. On a trip to California in 1976, four of us had a ten-course dinner with wine at an Italian restaurant in Stockton, called, of all things, Murphy's. The total bill was $26. Too bad the commute from New York to Stockton is so expensive or we would eat all our meals at Murphy's.

These notes are woven in between various sketches, including two of a tragic road tie-up on California's Interstate 5 in 1978. This highway south of Bakersfield used to be called the "grapevine" because of its many twists and turns, and its downgrade was the scene of many a runaway truck. It had been completely re-engineered, but on this day an unusually rainy season caused an entire mountain to avalanche onto it, burying cars and trucks. There is also my gas-station-stop sketch of Mount St. Helens several years before she most recently "blew her top."

My sketchbook is spiral bound, which I prefer because the pages lie flat. The size is usually 8x10″, convenient for fitting one or two sketches to a page.

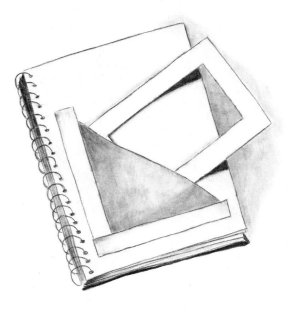

At the back of the sketchbook I make a pocket to hold a small mat approximately 4x6″ inside and 5x7″ outside. By tracing either inside or outside I can quickly make one of two different-size rectangles, depending on the size sketch I wish to make. Naturally, one does not need to enclose every sketch—as some of them can be vignettes—but enclosing does help in arranging many compositions.

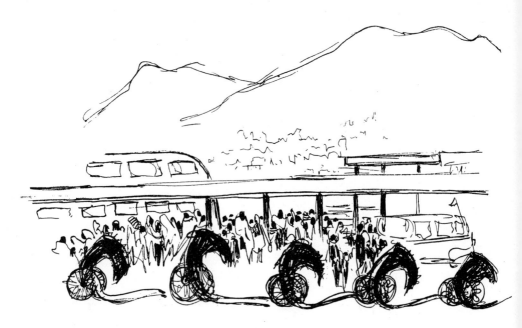

Pentel-pen sketch of rickshaws at the Kowloon-Victoria ferry, Hong Kong, 1967.

All the sketches and drawings presented here, with the exception of those of my gear, were made on the spot. They are small—mostly in the 4x6″ range—with none larger than 8x10″. They were made during winter cold and summer heat, with and without curious onlookers and artistic enthusiasts, with beer, soda, or lemonade when water was lacking. But most of all they were made with enthusiasm, and that's a magic word. It is always fun to walk back through them.

Materials

To breed spontaneity, which is so important in sketching, materials should be kept to a minimum. Traveling with complete painting gear can tax the ingenuity and nerves, not to mention the muscles, of any artist. It is difficult enough to work in uncontrolled environments: sun, wind, people, insects, sudden showers, or any of many distractions. The balancing act alone, sometimes in confined quarters, is hazardous enough without the added burden of trying not to drop something while you are watching out that your gear isn't "liberated" from your person.

As every artist knows, half the fun in art is searching for just the right equipment for you. My materials include an 8x10″ spiral sketchbook (Aquabee makes one in several sizes and weights of paper). This size is large enough for one or two sketches per page yet small enough to fit in most gear bags or large purses. My paintbox is a Winsor & Newton box, 7½″ in length, but I believe it is no longer being made. (Frankly, I use it more for sentimental reasons than for its ease of handling). It is a conversation piece: When it is open, the lids fold out into two mixing trays. There are small ceramic cups for paints, and the front end, shaped like an oval cup, slips off, latches into a slot in the lid, and becomes a cup to hold water. (See the diagram on page 16.) You can make your own water holders by cutting a small parsley tin, leaving a lip on one side. Bend this lip over and hook it on your palette.

There is a variety of small metal or plastic watercolor palettes available in all sizes. As I prefer tube paints, I like an empty, medium-size box without pressed or cake paints. Extremely miniature palettes are good only for extremely miniature sketches.

The palette has two finger rings that make it possible for me to hold it between my left thumb and index finger. With my sketchbook resting on my left wrist and forearm, my right hand is completely free to wield the brush. The water holder fits into a slot in the palette, as indicated by the arrow.

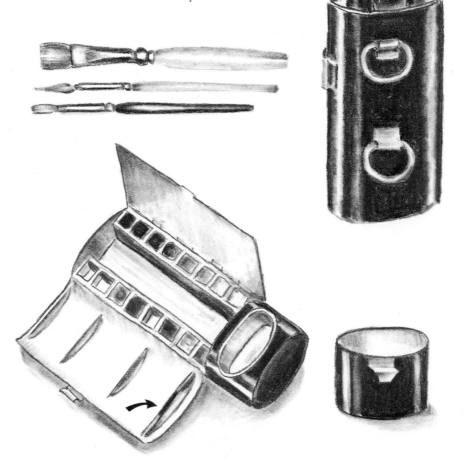

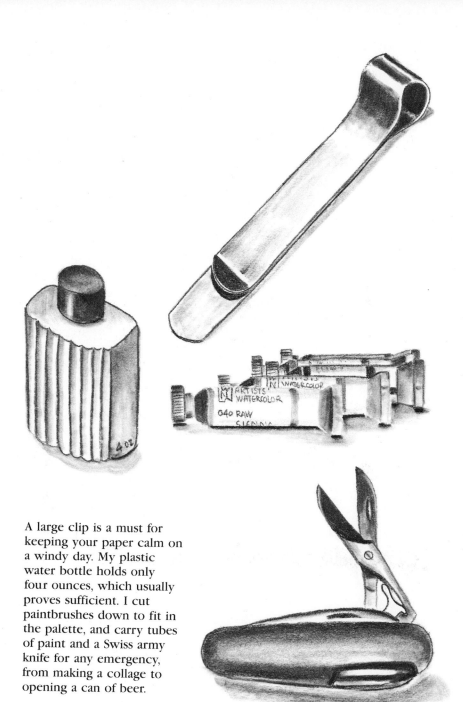

A large clip is a must for keeping your paper calm on a windy day. My plastic water bottle holds only four ounces, which usually proves sufficient. I cut paintbrushes down to fit in the palette, and carry tubes of paint and a Swiss army knife for any emergency, from making a collage to opening a can of beer.

My colors for sketching are:

burnt sienna	alizarin crimson	Winsor green
burnt umber	Winsor red	Payne's gray
raw sienna	Winsor violet	
Indian yellow	Winsor blue	
cadmium orange	cerulean blue	

I carry my water supply in a small three-ounce plastic bottle. And with me are always several plastic sandwich bags, one with tissues in it and the others available to hold any dirty or wet tissues until I can properly dispose of them. I use three brushes of sable or imitation sable—a ³/₈″ and ⅛″ bright (square tip) and a Number 4 round. (This also is a matter of personal preference, but these tools seem to work for me.) The handles are cut short so they will fit in my palette and, if I am going to make a sketch larger than 4x6″ or 5x7″, I increase the size of my brushes a little.

Other items such as pens, pencils, erasers, a Swiss army knife (with scissors), and a tube of glue travel in a small, zippered pencil case. My total gear weighs no more than about two pounds, and I have a marvelous time shopping for assorted purses or totes to suit my artistic needs! I might also add that as yet I still have not found the "perfect" bag, and go on happily searching.

The Sketchbook as a Manual

V alue study is perhaps one of the most misunderstood and ignored facets of art. It is not my purpose here to go deeply into a subject already exquisitely defined by other artist-authors, but rather, since this is a book on sketching, to show you how I applied the exercise of value study to my work.

A gray value scale, simply defined, progresses from light (white) to dark (black), with seven shades of grays in between—two light, three medium, and two dark. (See the value scale on page 22.) All colors have their own scales of value from pale tint to as deep as it can go, so in choosing your color scheme bear in mind the tonal limitations. For instance, cerulean blue can never go too deep but thalo blue can go very deep.

I started planning scenes using only white, middle gray, and black, limiting them to diagrams and not shaping them into little pictures. I tried to keep simplicity foremost in my mind and I found that the simpler the approach the more successful my sketches. Try to utilize every spare moment—choose a scene indoors or out, and make a small, quick, three-tone (white, middle gray, and black) diagram. In the beginning, reduce the subject matter as much as possible to geometric shapes.

Gradually I began to add additional diagrams in color—quick color notes composed before the light dimmed or the scene changed. After some practice I found it easy to tackle more intricate subjects and finally to make quick color studies without going through the first tonal study. These experiences made it possible for me to think in values while I was painting in colors.

If I find that the sketch has failed (not everyone can bat a thousand all the time), I go back to basics and make a tonal sketch

to try to solve my problems. Composition is another bugaboo: because I made small tonal diagrams at the start I was able to select from several simplified scenes elements that were important to me or that had caught my eye in the first place. These uncomplex "gray" scenes enabled me to "see" my subjects more quickly and not waste vast amounts of my paper or, much, much more important, my time. Paper can be bought; time can't.

To my chagrin I must admit that it took me quite a few years before I acknowledged the importance of this approach. I felt I knew what I was doing and did not need this planning. Then I encountered an inscription in Burmese, which translates, "To fly you must not only have wings but flap them." And I awoke to the fact that a small amount of additional work at the beginning can pay big dividends. So I began with simple three-tone value sketches such as those on pages 23, 24, and 25.

Six Views
and Other Sketches

For our purposes small value sketches should be done in white, middle gray, and black only. (Values 1, 5, and 9). Your value sketches will be more help to you if you keep them simple. Sometimes simple bands will provide you with your "road map"; other times a bit more intricacy may be needed. But keep details to a minimum: try to think and paint in geometric figures, utilizing the square, circle, triangle, cone, and other basic shapes. Leave all frills aside and save your enthusiasm for the color sketch or bigger picture. You can get fancy later!

If you sew, you already know the value of using a pattern to cut out fabric; a cook uses a recipe, and any traveler has, at one time or another, been grateful for a good road map. This is what your tonal sketch should be—a good pattern, recipe, or road map.

The following pages contain six tonal diagrams, all of the same scene, which were made one day to show some students

Pentel-pen sketch, Tangier, Morocco, 1969.

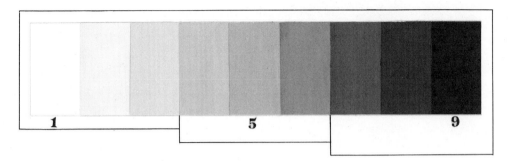

Gray value scale, a progression from light to dark.

how to arrange values to suit the moods of nature or, what is more important, to suit the moods of the artist. Your sketchbook should be brimming with your sketches and your impressions.

All these approaches are valid, for nature's moods are legion, and it is for you to decide what feeling you want to impart. Let nothing stand between you and your way of setting down what you see or what you feel. Always remember that it is your picture, so choose your mood!

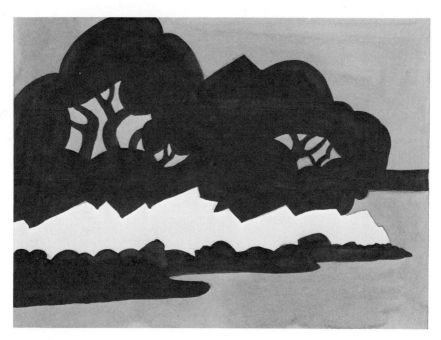

A suggestion of early morning (above), with the sun just coming up behind the trees and the rocks standing out light against the deep green foliage.

Now the values indicate a deepening sky (below) such as would appear if a storm were coming up. So deep is the sky that the trees appear light by contrast.

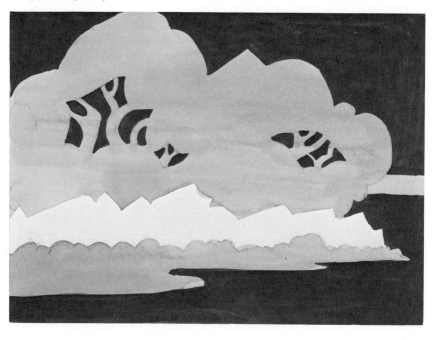

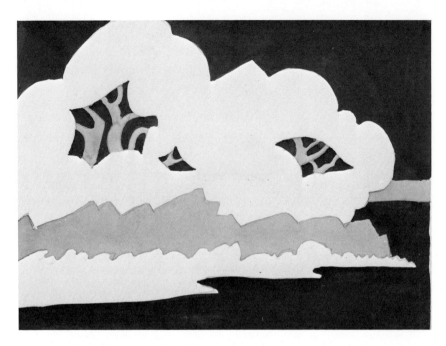

It is midafternoon (above); the sun is high and the rocks are shaded by overhanging trees.

Then there is lovely afternoon light (below) that brushes the trees and sea with glitter and makes the rocks appear dark and solid.

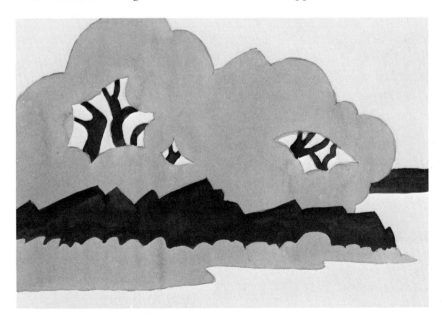

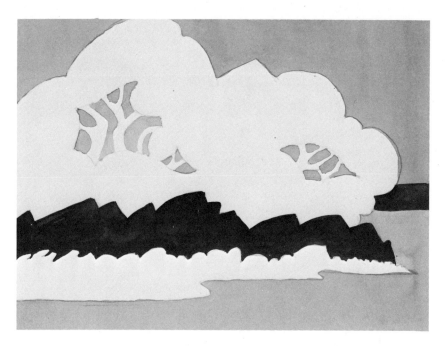

Here we have light trees (above) with perhaps a fog coming in behind them and the rocks strewn with dark-brown kelp.

The same scene (below), but with moonlight on the trees and a sandy beach.

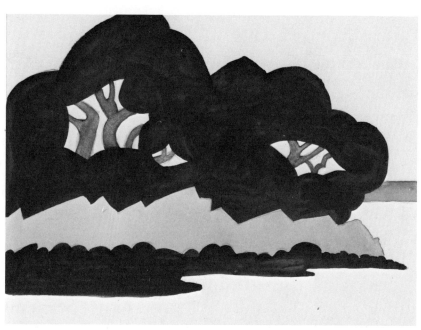

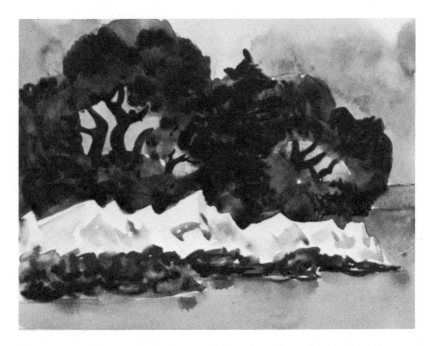

Two watercolor versions of our subject (see the color section for color notes). In one we have a bright sea on a warm day and sun-drenched rocks. In the other, a deepening sky and a dark sea running. The leaves may be turning; the air is brisk.

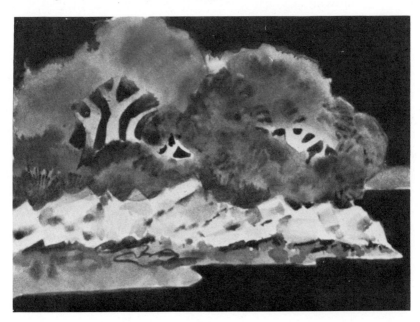

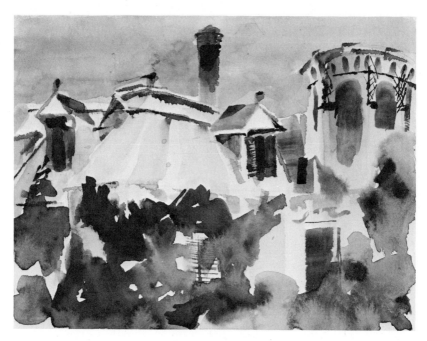

A Charleston roof.

On the following pages are tonal diagrams of an old flour mill in the process of being demolished, shrimp boats, and a cityscape.

The top sketch on page 30 is one I made as our class met at 17th and Ball streets, in Galveston. I found the scene a little less than stimulating. In the second sketch, I rearranged things to try to get a "handle" on a better or more exciting dimension. Had I started to make any kind of painting at this point I would have been disappointed, then frustrated, and finally bored.

After the second sketch I warmed to the idea and went on to make the third sketch, just putting in fences, balconies, windows, and doors wherever I thought they would look best in relation to the scene.

This is a good exercise in selection. Make a gray sketch of the scene as it is then make others in which you add shapes, change shapes, reverse values, or slant forms so they make dynamic angles. This will help limber your imagination.

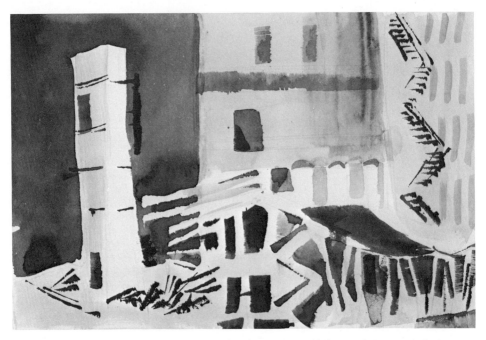

I sketched an old flour mill in Galveston in 1974 (above), using a dark sky as a foil for the tower. The same scene is depicted below, but with values reversed to show a light sky behind a dark tower. A reversal can help you decide which approach more nearly fits the essence of the scene.

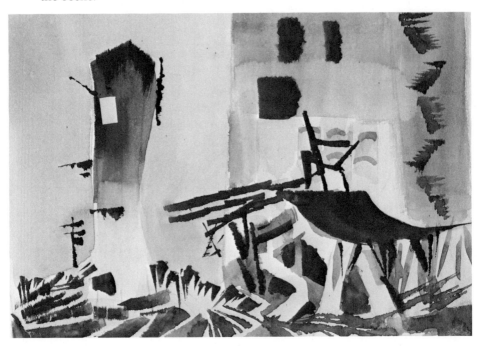

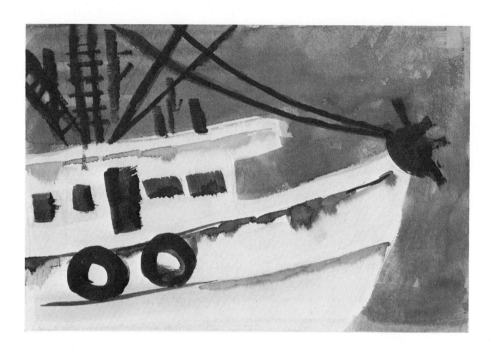

Two Payne's Gray sketches of shrimp boats on the Gulf of Mexico.
(See the color section for color notes.)

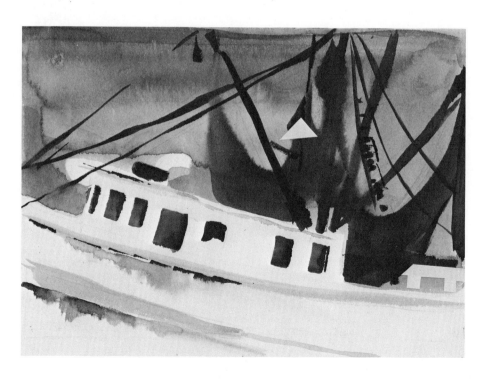

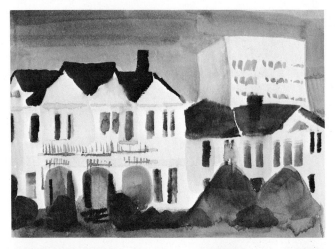

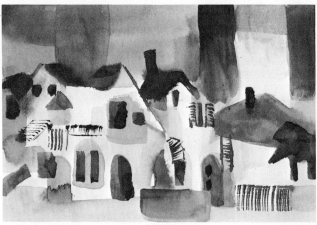

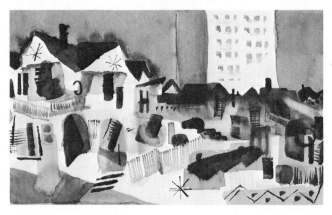

Three views of 17th and Ball streets, in Galveston.
Despite the fact that I enjoyed semi-abstracting this
scene, I did not feel the subject matter was worth
going into color notes for.

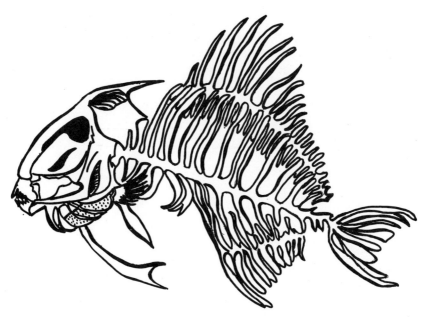

Pentel-pen sketch of a fish skeleton. The Museum of Natural History, New York City.

Following are more value sketches of figure and still life from the Art Students League in New York. On pages 42 and 43 I had fun inadvertently turning a still life into a cityscape. In the first sketch I was trying to determine a quick way to show bottles against a very exciting backdrop of colorful prints. It didn't really capture the spirit, so I made a second, which turned out to be even more of a dud. "Back to basics," I cried, and did sketch three; upon completing it I realized that I had the perfect approach to a scene I had been unable to handle several years before: I had discovered how to approach a sketch (of the Blue Mosque in Istanbul, sketch four) in a simple and straightforward, uncluttered way. This is what we refer to as the "spirit" of the scene.

So yes, your sketchbook as a manual should contain tonal sketches, whether for landscape, figure, or still life. Quick impressions should take no more than five or ten minutes, allowing time for your paper to dry in spots if need be. Do not try for miniature paintings, but, rather, try to capture the scene's "spirit." To recap the points in the use of the sketchbook as a learning manual: re-

member to make your small diagrams in white, middle gray, and black; keep them simple; and use geometric designs where possible. As you progress, add color notes. In a very short time you will have a collection of sketches to admire.

For those of you who have been fighting the problem of value as well as composition, there is an old Chinese proverb to recall: I hear, I forget. I see, I know. I do and I understand.

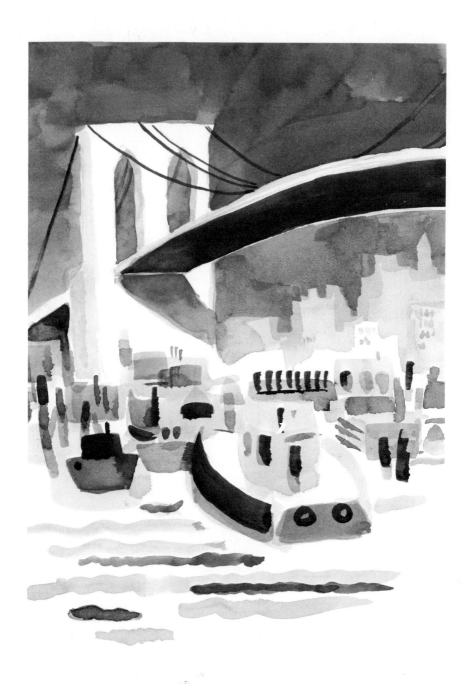

Completed in 1883 and a veteran amongst bridges, New York's
beloved Brooklyn Bridge as seen from the Brooklyn shore.

Two tonal studies. Value
sketches of the figure can
be utilized just as
effectively as those of still
life or landscape. (See the
color section for
completed color versions.)

Life class, Art Students League. Trying to keep it simple.

A model in two distinct value studies. Exercises such as this help you
determine which mood you prefer, and are more efficient than finding
out after you have started your painting that you should have done it
another way.

Two still-life studies in Payne's Gray. (For color notes, refer to the color section.)

A very quick pencil study plus a gray value sketch for a series of Protea paintings that I later painted using only three colors: AB (Antwerp Blue), PM (Permanent Magenta), and IY (Indian Yellow).

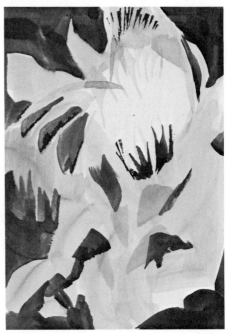

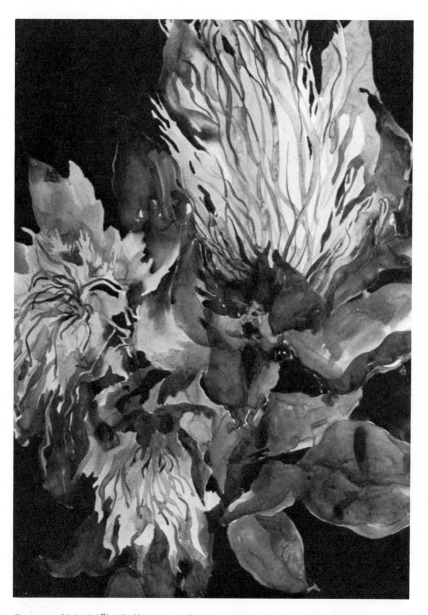

Proteas (28x32″). Collection of Mr. and Mrs. Eugene E. Marble.
Watercolor made from the preceding sketches. I increased the number
of flowers from one to three but stuck to using only three colors
(refer to the color section) to prove that a limited palette can give
you a tremendous variety.

Two studies in grays from subjects in my studio. Top: Dried leaves and flowers amid assorted paint jars. Bottom: Murex shell.

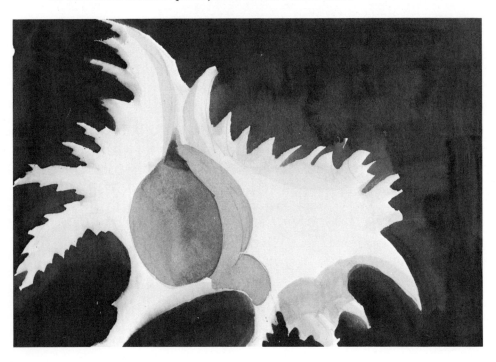

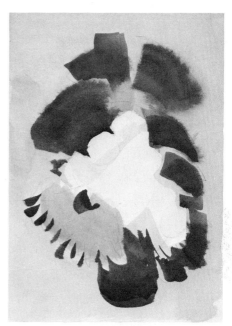

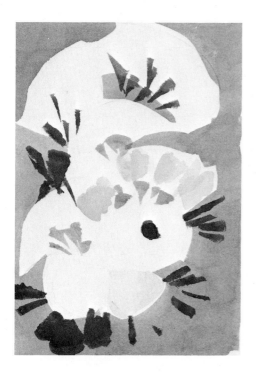

Floral studies in grays, prior to
making color notes. (See the
color section for finished
color notes.)

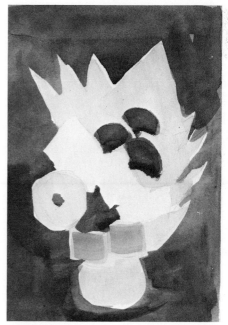

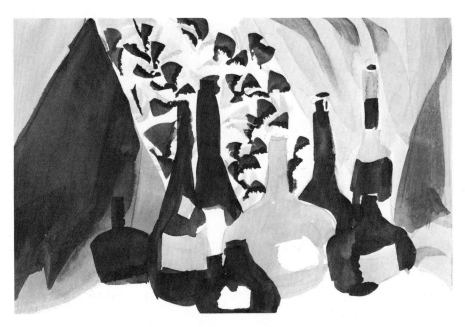

Above, my tonal sketch of bottles against a dazzling array of fabric. It does not show organization. Below, the same subject after an attempt to make it more interesting. It came up zilch.

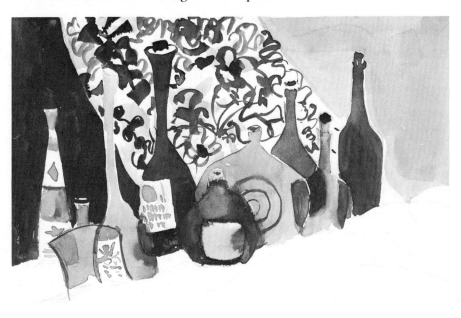

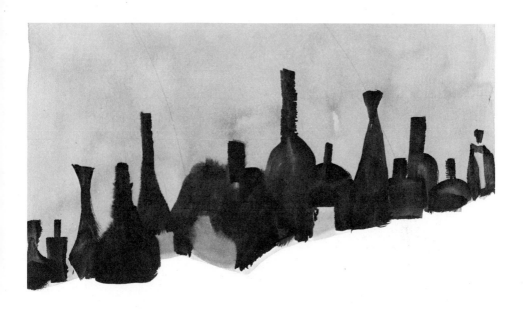

A return to basics and black, white, and gray; and then, using this impression, on to . . . voila! A quick study for the Blue Mosque, in Istanbul.

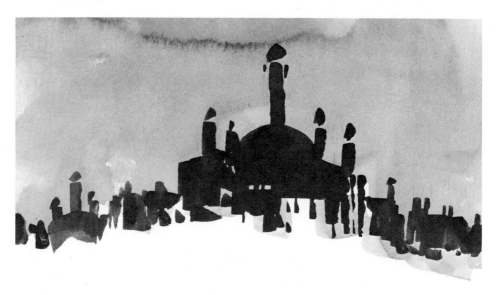

A collage of an imaginary monastery, made with gray papers.

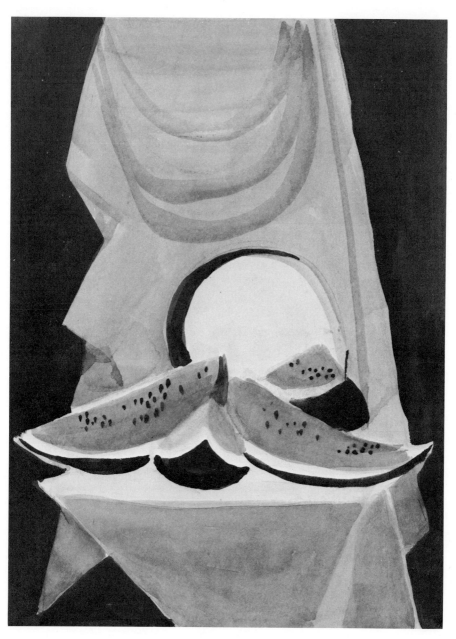

Watermelons.

The Sketchbook
as a Sourcebook

Your sketchbook should be used to record any scene or event that might prove useful to you in the studio. Photographs are good to refer to for details, and so can certainly add to the portrait of your subject. But not everyone has a camera with him all the time; we usually do have pen or pencil.

In a photograph, everything is captured. If you use a microscope on a 35mm slide, you can often read the street signs or even see inside windows. Fascinating, but sometimes details draw your attention away from what first interested you in the view. Make every effort to be bold and sparing in your sketches. As you begin, ask yourself these questions: "Is that stray cat really necessary? Do I need that street lamp obstructing the view of the doorway? What would happen if I parked that big car on the other side of the street?" Now you will say, "But that is the way it was," and I will reply that your paint brush is a magic wand that can wave away stray cats, street lamps and cars, or anything else unwanted or unnecessary.

Gradually, I began to produce studies of flowers and trees to be used as models in or perhaps inspiration for my paintings. I am particularly fond of nature as the subject of my major works, and collect as much material as possible. Try clipping one small leaf from every plant and tree that you see during the course of one week. The variety is astounding!—there is nothing unimaginative about nature. It is those of us who do not use our power of observation who are unimaginative, and an artist must strive to keep his inquisitiveness and fancifulness alive and well. If you make drawings of trees, flowers, and leaves, they almost become a part of you. Perhaps you prefer machinery or old, rusty cars. Fine! Collect

sketches of them, paying attention to the dynamic shapes of gears, fenders, belts, wheels, dented doors, or jagged glass.

One of my early works was inspired by the inside of an old typewriter — a far cry from a woodland scene, but I did enjoy doing it.

However, doing two or three value studies back in those days would have made things a great deal easier.

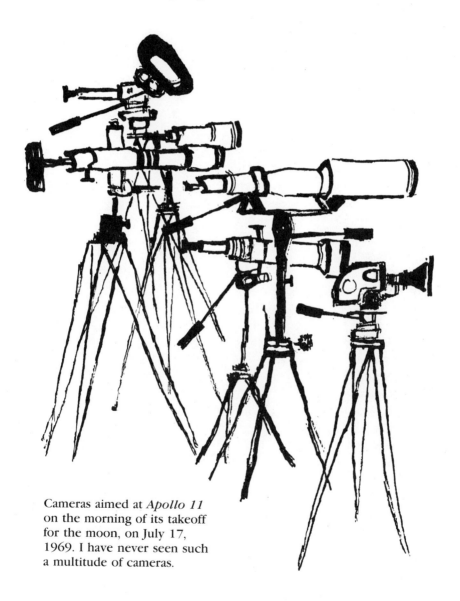

Cameras aimed at *Apollo 11* on the morning of its takeoff for the moon, on July 17, 1969. I have never seen such a multitude of cameras.

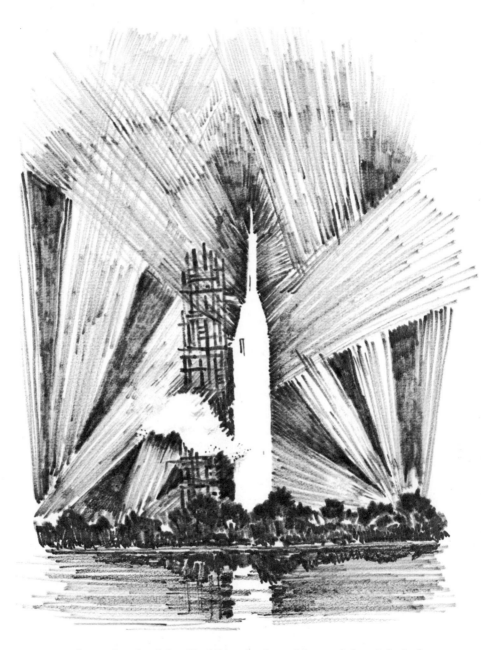

Pentel-pen sketch of *Apollo 11* on the launching pad the night before the historic flight to the moon. After I saw this, I mentioned to the director of the program that the ship resembled a slim bride, all in white, with the gantry lights sparkling and shining and looking every bit like her jeweled veil.

The artist sketching for NASA at Cape Kennedy. (Photo courtesy of Mario Cooper.)

The National Gallery in Washington, D.C., was mounting an exhibition on the Civil War, and the Curator of American Art, H. Lester Cooke, found that some of the most interesting articles in the exhibit were quick sketches made by participants in the conflict—from foot soldiers to reporters. That is what started the NASA art program. After all, every nut, bolt, and screw on our vehicles had been blueprinted, photographed, and x-rayed, but there was no record in art. A program employing the talents of many of America's finest artists was initiated, and I was fortunate enough to be asked to contribute my time and talents on the *Apollo 11* flight to the moon. Many sketches and paintings became the property of the National Aeronautics and Space Administration and are on view in that museum, in Washington.

My *Firefly to the Moon,* with many other NASA contributions, has toured all over the world. (Permanent Collection of National Aeronautics and Space Museum, Washington, D.C.)

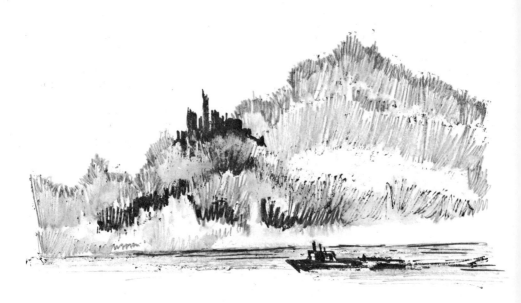

Quick sketches of castles along the Rhine River, in Germany. I was so excited by the beauty of the river valley that I began to change the film in my camera without rewinding it first.

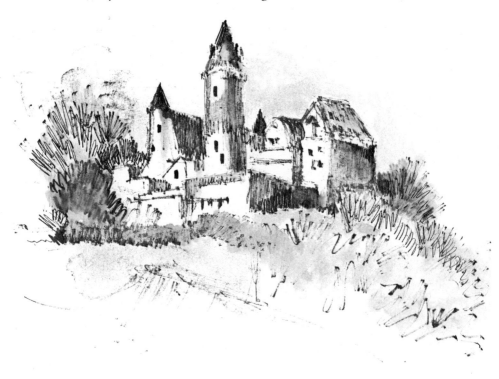

Above, a large tonal plan in pencil on tracing paper for my painting *Winter on the Rhine.* This was a simple layout to determine where I wanted the larger masses.

A progressive slide below (here in grays) of the beginning of the painting. A very poor slide, but it seems to be the only one I have. At this stage the "impression" is merely that—a series of designs on my paper made by, among other things, tissue or rice paper wadded, dipped in paint, and then "printed" on the paper.

Winter on the Rhine (23x33″). Collection Frye Museum of Art, Seattle, Washington. On the previous page, you see two steps leading to the completion of this large painting, which was inspired by a trip along the Rhine. (See the color section, in the middle of the book). My sketches, together with a few slides, provided enough information for me to work from. None of my sketches was the sole inspiration—all contributed to the overall "fantasy."

What follows are some studies of trees and vistas. Most are practice sketches, starting out simple and later becoming a little more complicated (such as the pencil sketch on page 59).

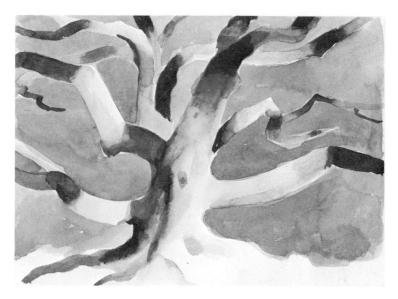

Above, a tree, Clearwater, Florida, 1975. Below, a tree, Central Park, New York City, 1978. Although it has lost its top and the once fabulous roots have been decimated by overeager schoolchildren, this tree has been a favorite of mine for the past fifteen years. I must have painted it twenty times, and will continue to do so because each time it becomes a different picture.

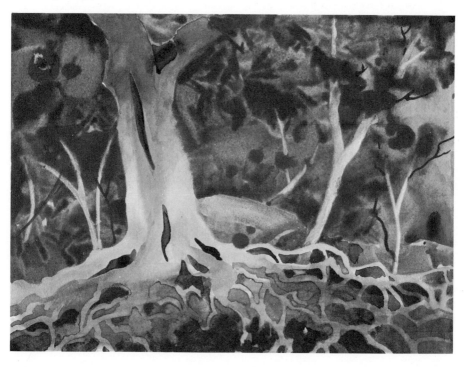

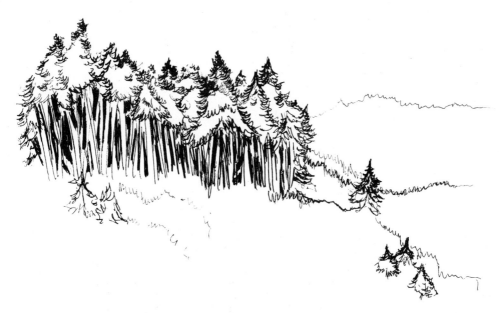

Above, mountain vista, near Grants Pass, Oregon, 1976. Below, pen
sketch of pines near Tumwater, Washington, 1976. Two quick
countryside impressions.

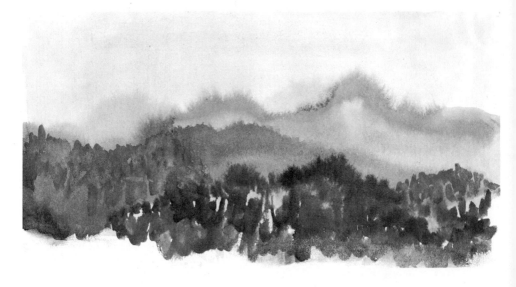

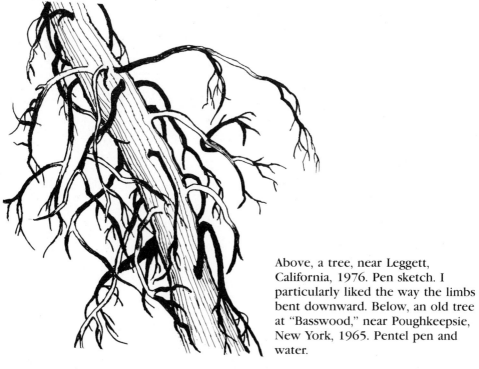

Above, a tree, near Leggett, California, 1976. Pen sketch. I particularly liked the way the limbs bent downward. Below, an old tree at "Basswood," near Poughkeepsie, New York, 1965. Pentel pen and water.

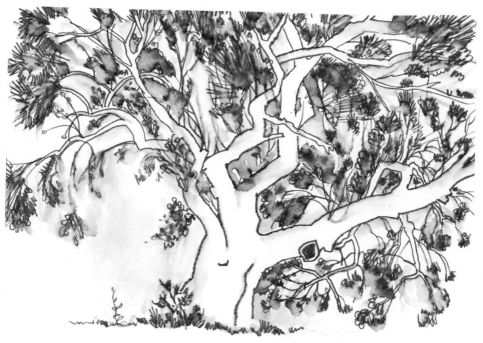

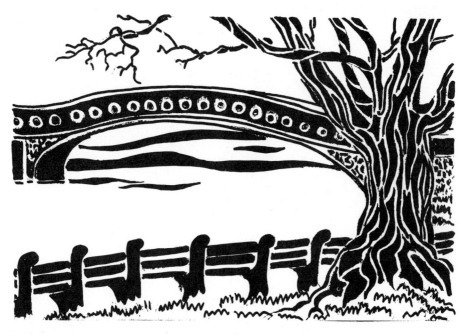

Above, a tree, Central Park, New York City, 1980. Pentel-pen sketch à l'Art Nouveau. Below, roots, Central Park, 1980. Pentel-pen sketch. This was merely an attempt to do the same subject in a slightly different way, trying to show the form by the direction and the size of the small shapes.

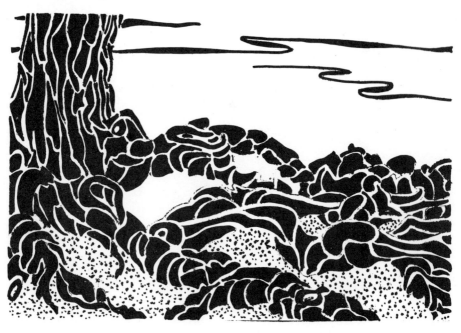

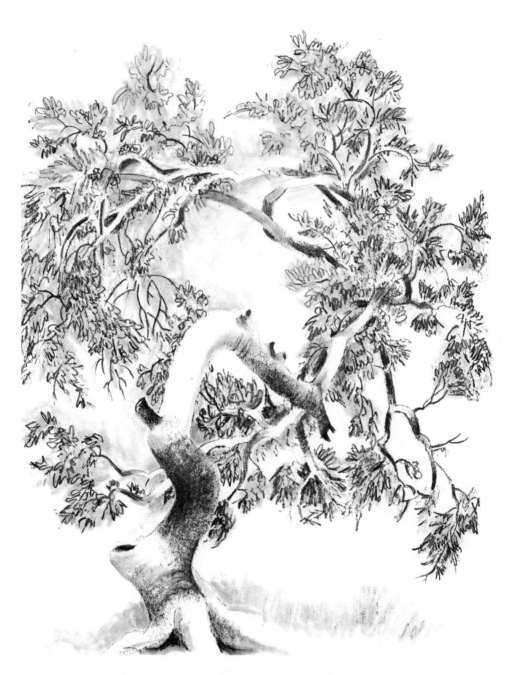

Pencil sketch of a tree in Central Park, using a more realistic approach.
It is important to study the way the values on the limbs change as
they bend and grow in their many directions.

Above, a progressive slide of one of my paintings (here in grays) in its preliminary stage. From this impression I will gradually tighten the composition, adding the figures to give it scale and defining the trees. Here is where my tree sketches come in handy. The finished painting, below: *Early Snow in the Siskiyous* (23x32″). (Refer to the color section.)

Above, *Hickory Revisited* (22x36"). Permanent collection of the
Environmental Protection Agency, Washington, D.C. Below, *Milkweed
and Sunflowers* (27x33"). Private collection. A painting such as this
will sometimes take me several months to complete due to the large
amount of small brushwork involved. In doing a work like this, I will
refer to my collection of sunflower studies and milkweed sketches.
(For color notes on both, turn to the color section.)

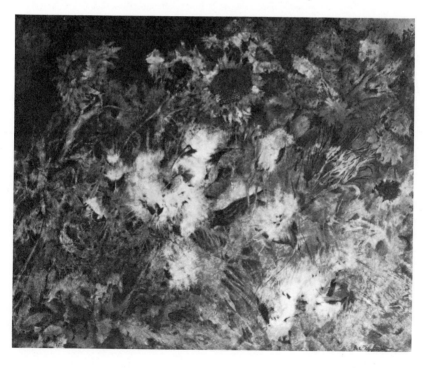

How to Wait
Without Waiting

My husband and I love to travel, and have had many happy flights around the country and around the world. Though not a nervous traveler I enjoy being prompt, and my only fear of flying is missing the plane. To humor me, my husband sees to it that we reach the airport with time to spare. But then, what to do with that time? I started to use it to record the beginning of each trip, sketching the plane and its functional surroundings and recording the flight number, airline, and date. It is intriguing, and tests your imagination, to take the same subject (such as an airplane) and sketch it from many different angles. I gradually added to my chronicle scenes from our hotel rooms, and my portraits grew into a pictorial diary.

It takes only a short time to make one of these sketches, and when your flight is called you need only pour the rinse water onto a tissue placed in one of your sandwich bags, fold your palette, grab your boarding pass, and silently board.

You may say, "What is the point of all these airport pictures? I could just as easily keep a list of flight numbers and dates." Ah, but remember, the point of sketching is to improve your artistic ability, and what better time to study than time that might otherwise be wasted? And of course, as your facility increases and you make a game of this, your enjoyment increases. My sketch of Trinity Church (frontispiece), for instance, was made as I waited to keep a dental appointment.

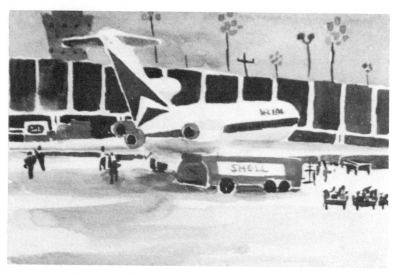

We were waiting, above, for Delta Airlines Flight 243 to Atlanta at LaGuardia Airport, New York City, on January 7, 1979. There was a slight dusting of snow on the ground, which made the yellow truck important. Below, view from Room 1605 of the Colony Square Hotel, Atlanta. Sketches from your hotel are the easiest— no onlookers, plenty of water, and, best of all, a place to sit.

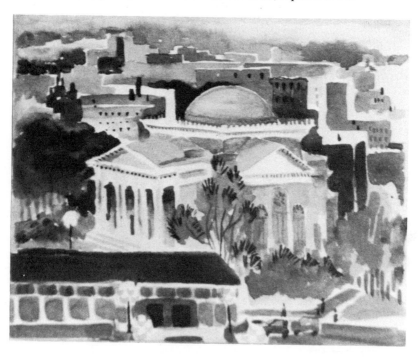

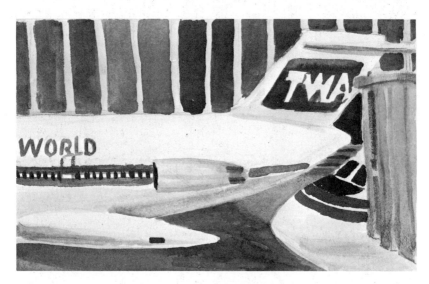

Waiting for TWA Flight 323 to Chicago, above. Sketches such as this should take no more than ten minutes. Below is the Atheneum in New Harmony, Indiana, December 10, 1979. Designed by Richard Meier, this is a gorgeous building full of light and air.

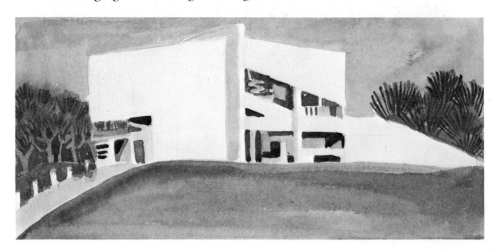

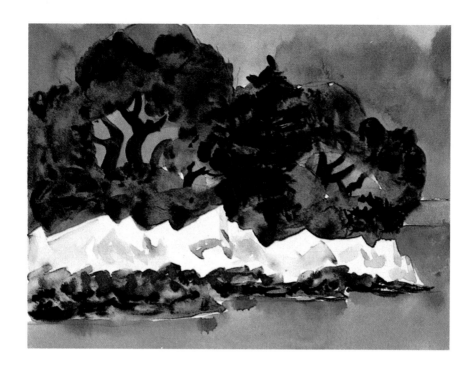

My color versions of the subject of the six tonal views. They're different: in one, the sea and sky are bright, while in the other darkness is moving in and there is a chill in the air.

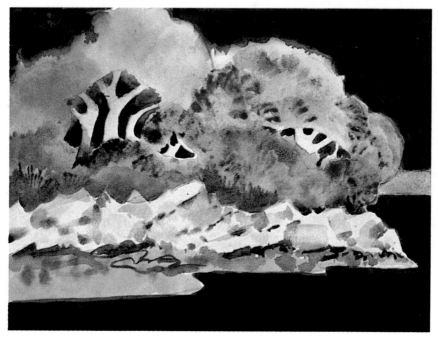

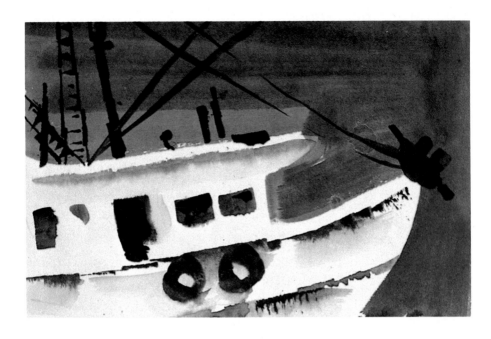

The gulf shrimp boats in color, prior to beginning a larger painting.

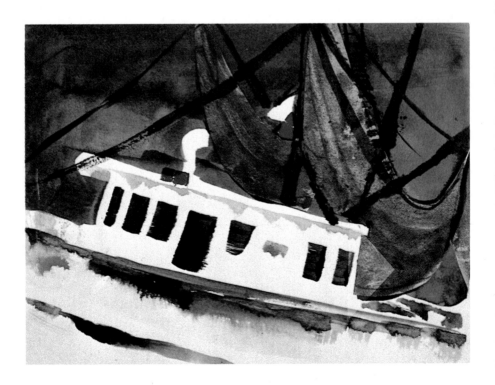

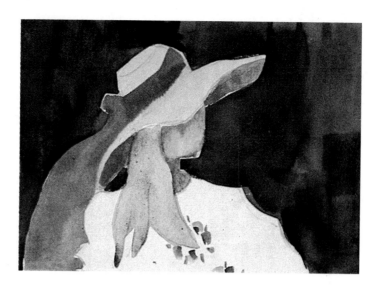

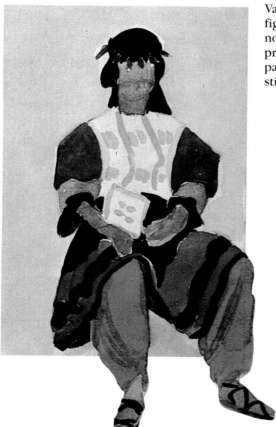

Value sketches of the figure, in color. Color notes are just as useful in progressing with a figure painting as they are with still lifes or landscapes.

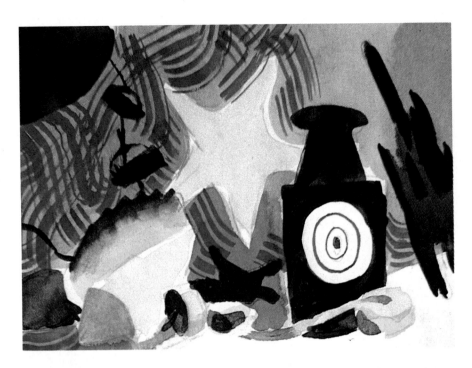

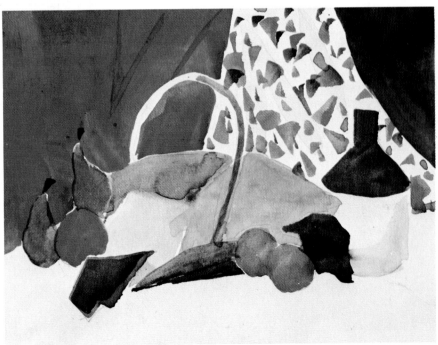

The still lifes, now in color.

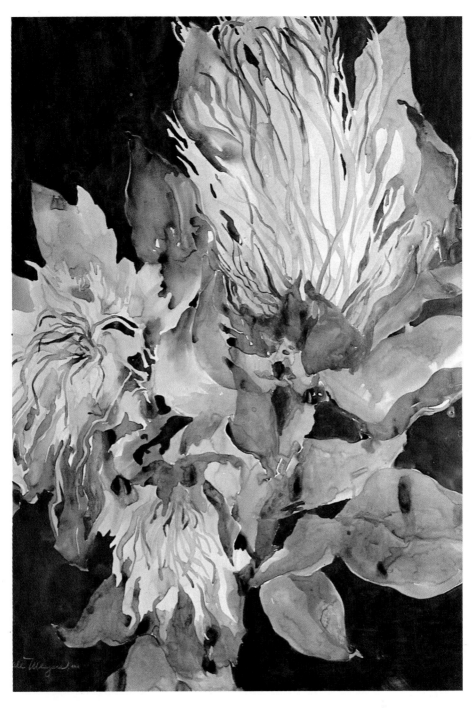

The three colors of *Proteas*—Antwerp Blue, Permanent Magenta, and Indian Yellow—allow a range of subtleties and intonations.

Floral studies in color.
Note the difference
between a light background
and a dark background.

Winter on the Rhine, complete after early renderings in which I began to catch the mood and plan the color.

Early Snow in the Siskiyous

Hickory Revisited in its final form.

The sketches at their many stages are invaluable in producing something such as *Milkweed and Sunflowers*.

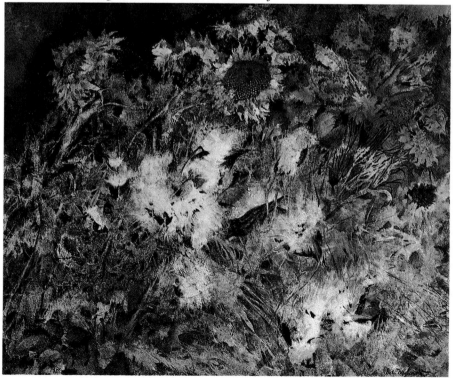

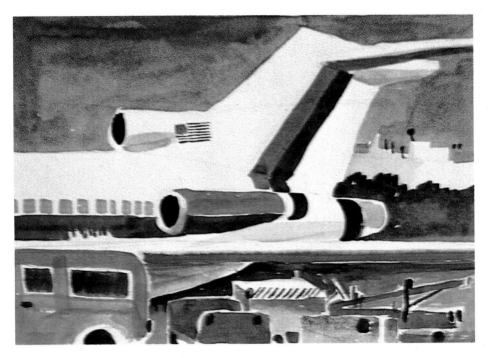

A restful Sunday, or "Domingo," to some—a busy one for us at JFK Airport, en route to Mexico.

Blanco Navidad from Mexico City!

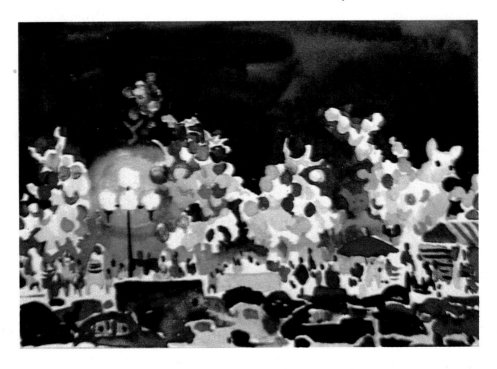

A burst of oranges on our way to Venice, Florida.

At Tampa International Airport, sketching away.

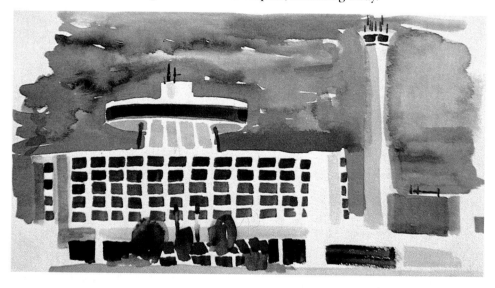

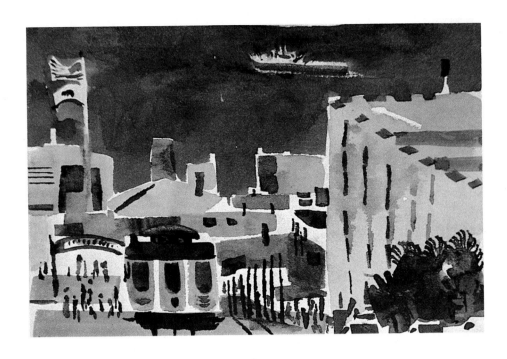

Hyde Street Pier and Coit Tower, in San Francisco.

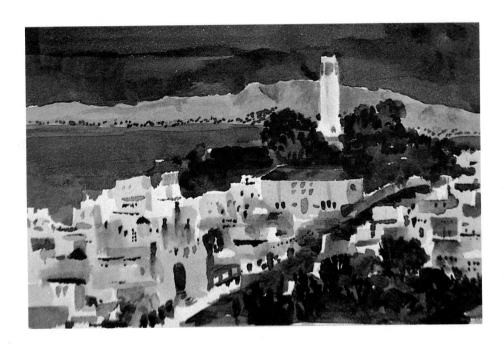

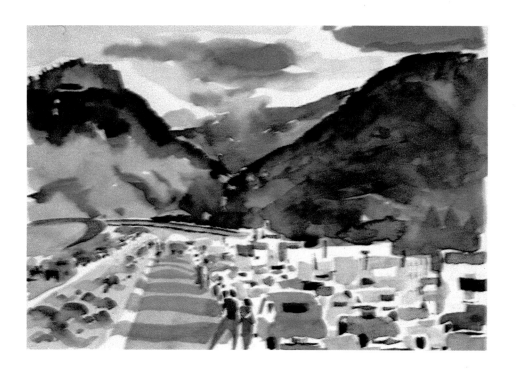

Above: highway tie-up . . . and, below, its cause, a California mud slide.

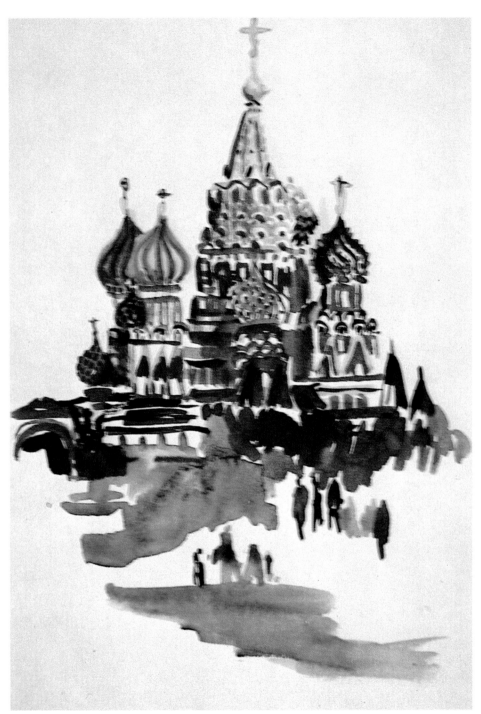

A triumph of Byzantine architecture in Russia's capital city.

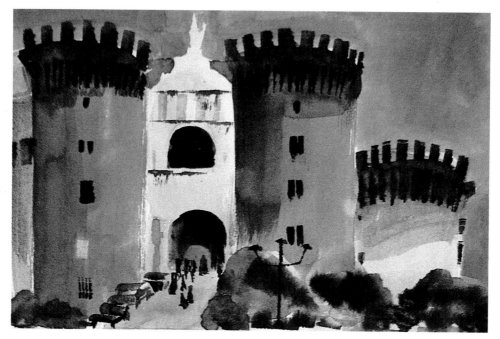

Above, Castel Nuovo, Naples—painted with beer instead of water.
Below: View from our room on Capri.

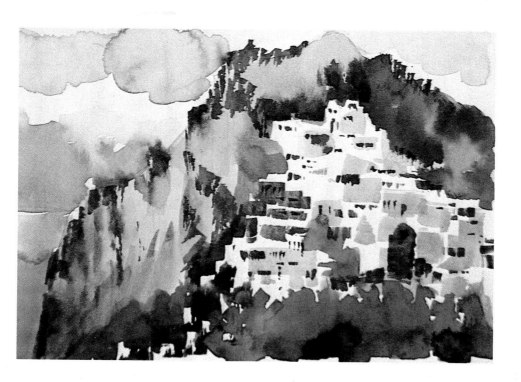

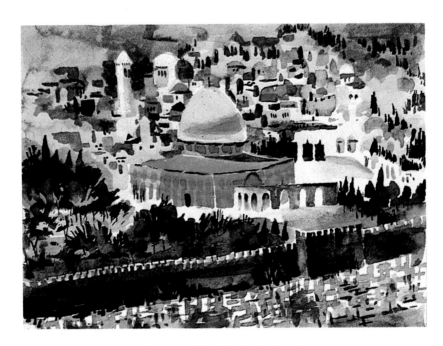

Dome of the Rock, in Israel.

A sepia composite, Jerusalem.

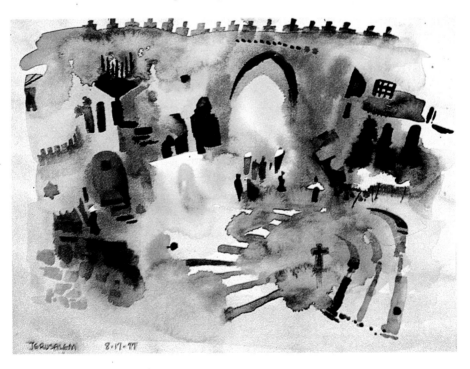

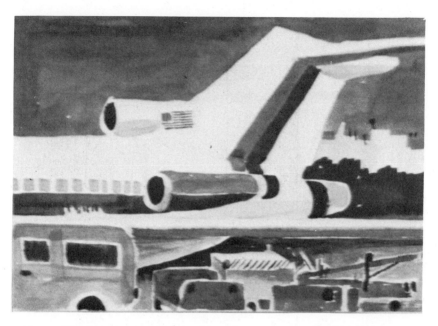

Above: JFK Airport, New York City, December 24, 1978 (Domingo).
Waiting for EAL Flight 901 to Mexico City. While you practice your
sketching you can practice your Spanish. Christmas night on the
Alameda (below), Mexico City. Lunes December 25, 1978. There were
mountains of balloons and *Blanco Navidad* over and over on the
loudspeakers. The celebration continued until well past midnight
every night for over a week. (See the color section.)

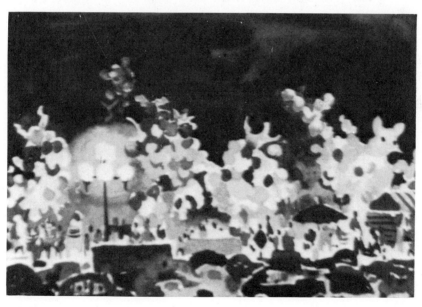

A countryside impression from the Martz Trailways bus on the way to Wilkes-Barre, Pennsylvania. On such a trip there is not time to catch specific scenes, but you can put down your visual perceptions.

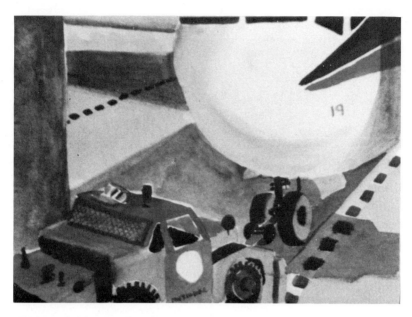

Waiting for National Airlines Flight 127 to Venice, Florida (above), September 9, 1979. This was a particularly fun sketch because the shades of orange were so appealing. Below, waiting for a change of planes to National Airlines Flight 442, Tampa International Airport, September 11, 1979. On any trip, I try to plan at least one sketch per day. (Refer to the color section.)

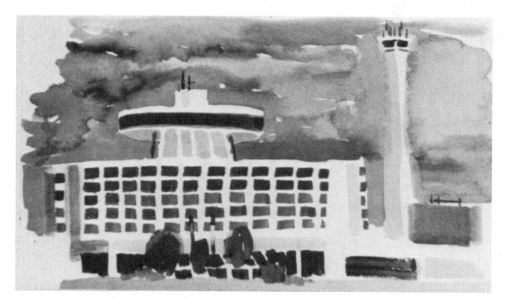

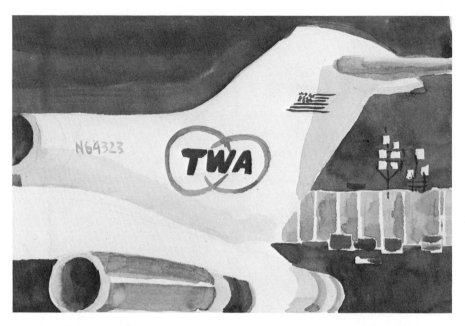

At LaGuardia Airport, New York City, above: waiting for TWA Flight 463 to Indianapolis, April 2, 1978. Below, the State Capitol Building in Indianapolis, April 3, 1978. This was a little complicated for a quick sketch, and thus required a bit more drawing than I normally care to use.

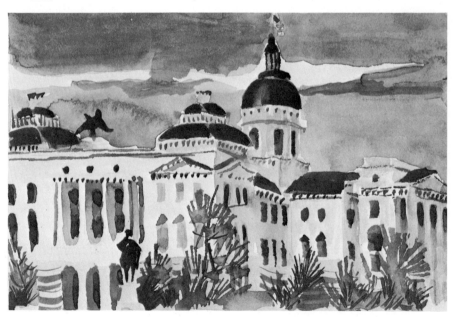

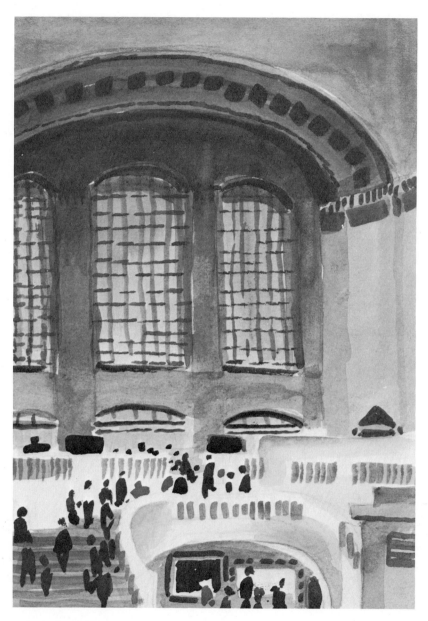

Waiting for the New Haven Railroad train at Grand Central Station, New York City, July 5, 1978. I stood in the corner sketching while holiday crowds milled all around. No one even cast me a curious glance.

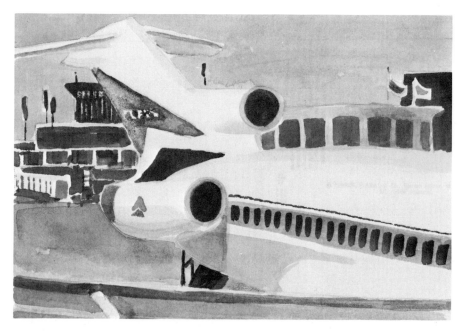

Above: O'Hare Airport, Chicago. Waiting for Delta Airlines Flight 867 to Evansville, December 9, 1979. We did not deplane from EAL Flight 606 when we stopped at Louisville en route to Newark, so peering through the plane window I made this sketch (below) of dusk settling over the International Harvester plant, December 10, 1979.

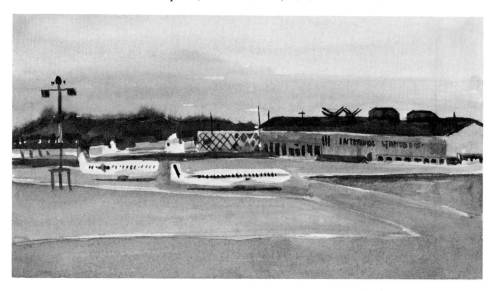

The Sketchbook as a Log or Journal

*W*e are flying from New York to Los Angeles at thirty-nine thousand feet. It is a hot July day, and visibility is unusually high. The country spreads beneath as the East Coast seashore rises casually into hills and then mountains. Rivers meander on their enigmatic ways between patchworks of tan and green. Groups of miniature houses huddle together as if in fear of the snaking concrete thruways, whose deadliness is accentuated by the coiling of their cloverleafs. There are oblongs, squares, and triangles of land dissected by the surveyors' transit and hacked apart by roads that come and highways that go. It is a marvelous view of this beautiful country that brings to life the maps that have fascinated me since childhood. All this land, on either side of which the seas crash on rocks of granite or undulate in sandy tidal pools. Here we have mountains that are jagged thrusts and there they are chopped off at the top as though by a meat cleaver. Our endless plains that grow the products to assuage our physical hungers but often evade our artistic ones.

As I write these thoughts in my sketchbook I wonder which state we are over. What vistas it holds and what exciting compositions lie hidden in seemingly commonplace sights!

I wonder how many paintings per acre there are in this country. One does not have to go to Tahiti to paint a marine or Zermatt to paint a mountain, although that is some mountain! I am not discouraging travel, an addiction I have no wish to shed; rather, I am curious as to how much we miss of the beauty, drama, and excitement here in our own United States. We too often ignore

our surroundings and instead feel that the perfect picture awaits us thousands of miles from home.

So, to start our sketchbook as a log or journal, let us begin with a sketch at the airport, train station, or dock, depending on what method of travel you are using. You can make a dynamic composition of the wings, jet engines, baggage trucks, or piers. Next will be a sketch from the hotel, creating a record of the room as well as a memento of the view. From that time on just seize the opportunities as they arise—sometimes there is only time for a quick impression. On one trip to California I recorded a tank truck as it was steam-cleaning an oil-holding tank for one of my brother-in-law's wells. The second sketch shows him discovering that the bottom of it was rusted away.

Then there was the episode of the unwary dove, and, on another occasion, our auto tour of the California, Oregon, and Washington coasts. The following pages show sketches of these happenings as well as those from many other parts of the country. There is one drawback to this form of remembrance, however: it is not always easy to get everyone to stay put while you are doing your sketch. Which may call for a bit of diplomacy.

In one instance, stuck for hours in a traffic jam on Interstate 5 just south of Bakersfield, I got out of the car and made a sketch of the scene. We finally had to turn back and spend the night in town, and the next day we found out why: an entire mountain, sodden with rain, had slid silently down and engulfed the highway and its traffic of cars and trucks. The following morning, as we traveled the opposite lane of the divided highway, we were able to stop long enough to catch the scene of scattered trucks and their cargos of oranges. As my sketches on page 84 recount, the sight was colorful; but later, under the mud, they found tragedy.

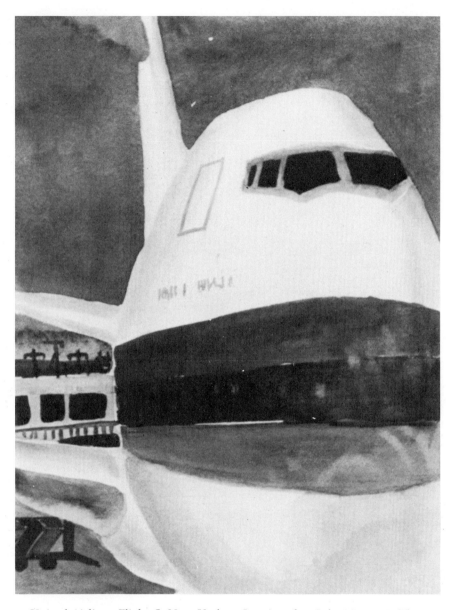

United Airlines Flight 5, New York to Los Angeles, July 13, 1980. This flight is affectionately dubbed the "Noon Balloon." We had so much time before takeoff that I was able to do quite a bit of sketching prior to boarding.

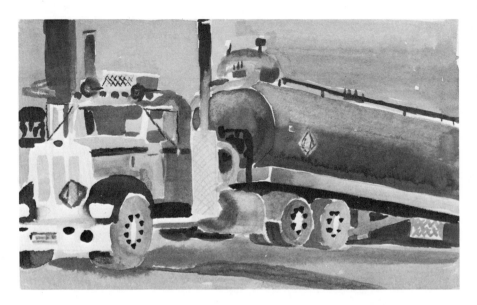

Carrasco Vacuum Truck Service (above) cleaning my brother-in-law's oil-storage tank, September 19, 1979. There was a complicated apartment house behind the truck, which I ignored in my sketch for the confusion it would have brought to the scene.

And when they got all through cleaning, they found (below) that the bottom had rusted away! C'est la vie.

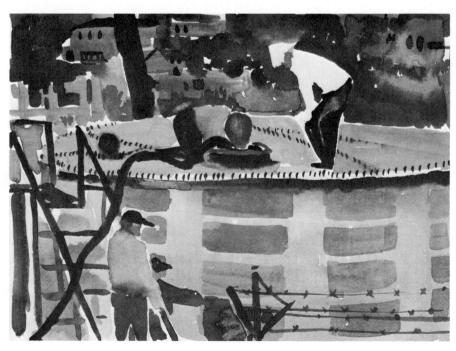

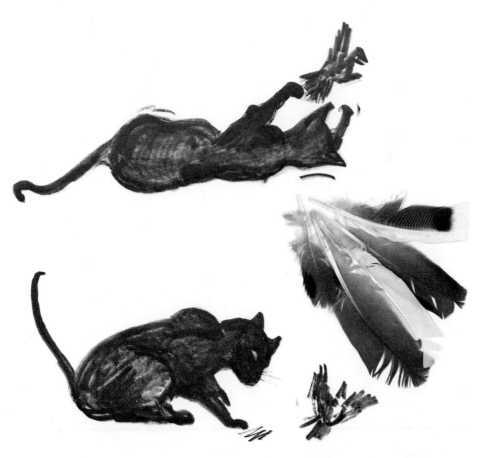

"Stuff" and the unwary dove, July 28, 1970. The bird got away but without his tail feathers. Pentel pen plus *real* tail feathers.

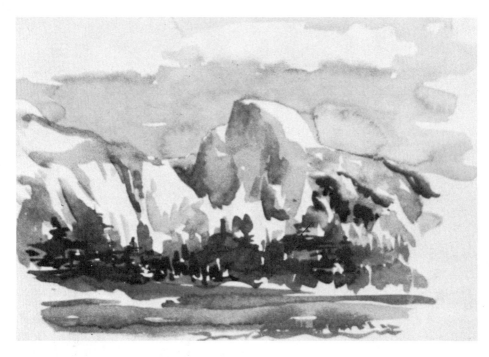

Above: Half Dome, Yosemite Park, California, August 25, 1978.
June Lake (below) in the Sierra Nevada Mountains, California,
August 24, 1978.

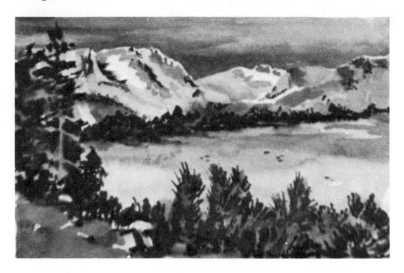

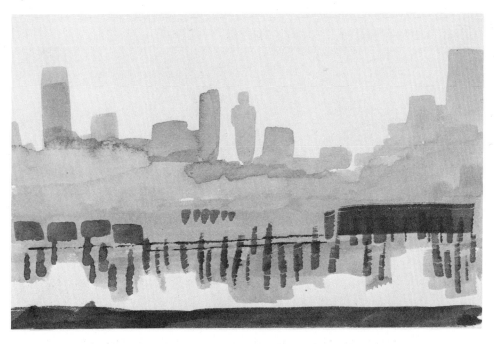

Two views, in Payne's Gray, of Fisherman's Wharf, San Francisco, July 4, 1976.

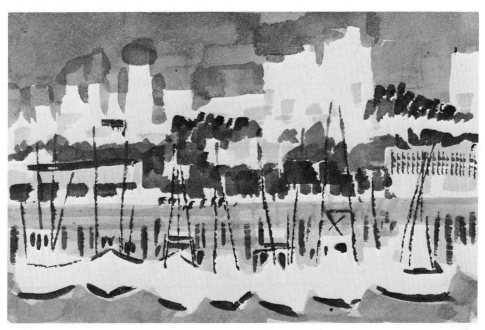

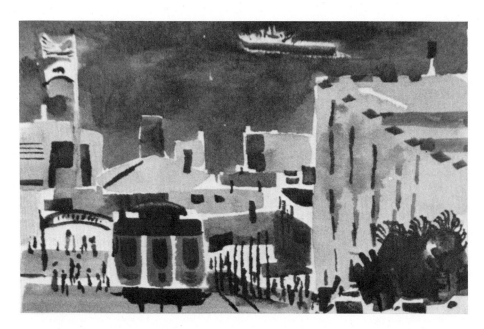

Above, Hyde Street Pier with cable car, San Francisco, 1978. Below,
Coit Tower—evening in San Francisco, 1978. Both of these appear in
the color section.

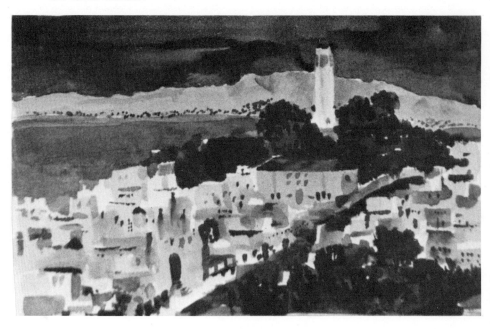

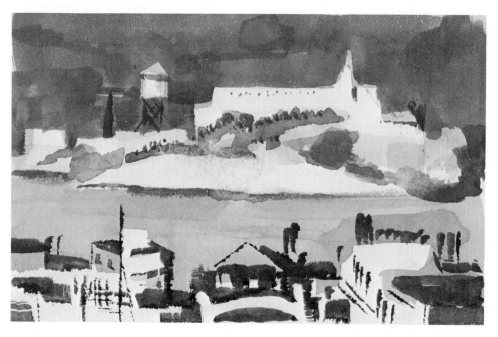

Alcatraz, July 4, 1976. Sketch in gray of "The Rock." I am sure you have noticed my fondness for strong, deep-colored skies.

Ticket on a cable car to Ghiradelli Square. We had cocktails at the White Whale, and sat beneath a whaling print done by Gordon Grant, a dear friend.

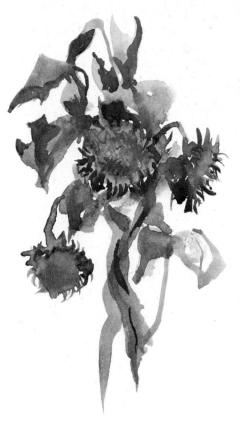

Opposite page:
Above, map of our route through the Olympic Peninsula, Washington, 1976. Below, quick pen sketch of a logging truck on the highway to Port Angelus, 1976. (It doesn't pay to try to pass one of these on a narrow road.)

Left: Steve's sunflowers, San Leandro, California, 1978. Flowers in my son's garden add to my store of memories as well as to my reference notes.

Below: Golden Gate Bridge, San Francisco, 1976. While I was doing this sketch, the powerful Pacific wind blew away my scarf and threatened to toss my sketchbook and me into the bay.

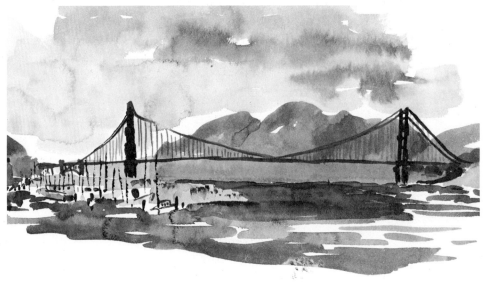

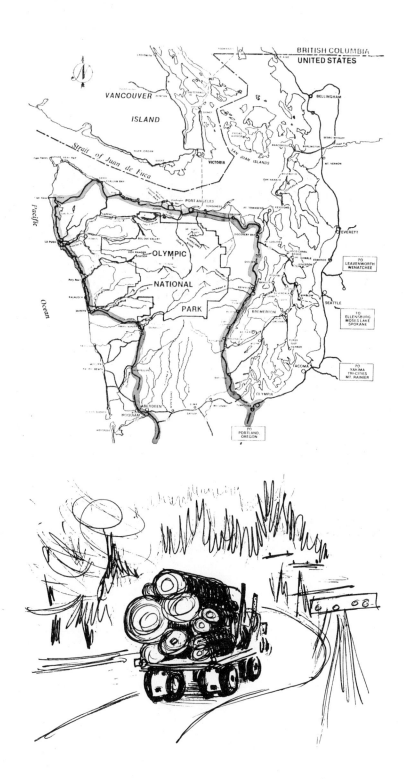

We stopped for gas on Interstate 5 in Oregon and I made this quickie of
Mount St. Helens—before she recently changed her profile.

Pen-and-ink view from Mountain View Motel, Room 122, Bishop,
California, 1978.

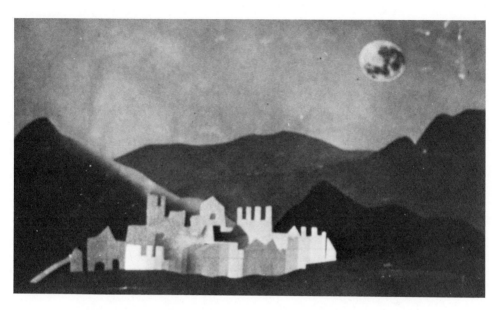

Collage of a California ghost town. This was done strictly from collected memories.

Stuff, Sam, and Minnie, my sister's cats. "This summer programming is a first-class bore!"

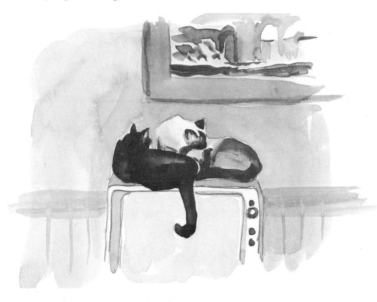

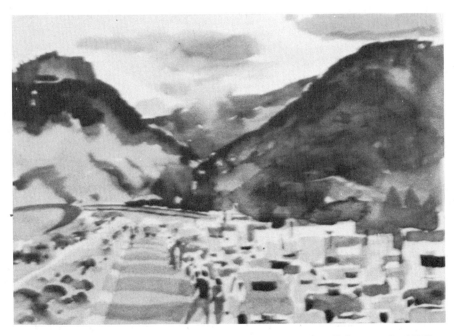

Traffic jam on Interstate 5, on the way to Los Angeles, February 5, 1978.

This was its cause—a tremendous mud slide on the "grapevine." (Refer to the color section.)

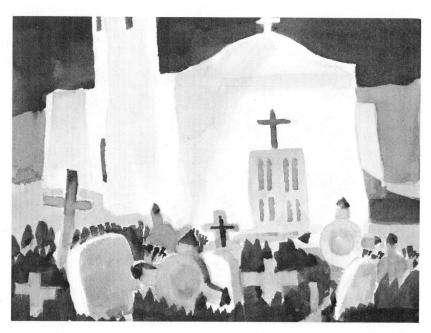

Church at Golden, New Mexico, 1972. This seems to be Motif #1 of the West.

Rocks near the Grand Canyon, 1972. A quick impression of the rock formations, made with Payne's Gray and a split brush.

Freighter at Galveston, above. And below, freighters at Pelican Island, 1974.

Skyline of Galveston, and the Galveston beach front from the Flagship Hotel. This hotel is built to extend over the Gulf of Mexico, allowing you to see deep into the water because of the building height and distance from shore. It is even possible to fish from your room, as I was startled to learn one day when I saw flipping, silvery shapes flashing upward past our balcony. At first I didn't see any fishing line. I guess the poor fish didn't either.

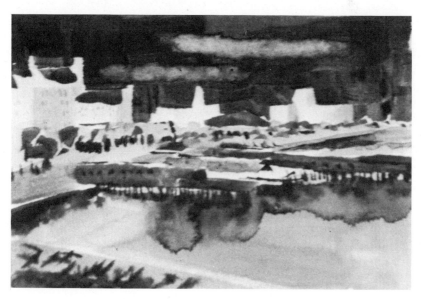

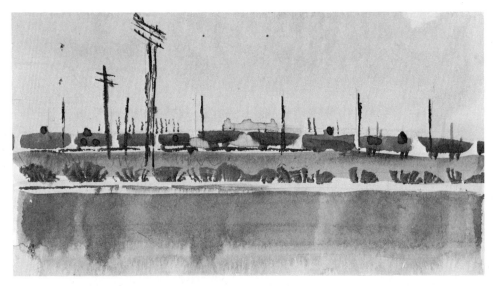

The constant traffic of trains hauling from coast to coast, as seen
(above) from Room 332 of the Hitching Post, Cheyenne, Wyoming,
1975.

Below, an old wagon in Cheyenne.

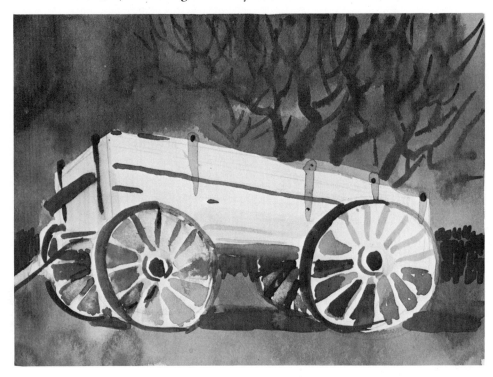

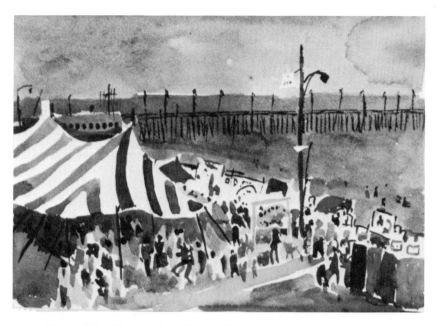

View of the Virginia Beach Art Show, above, from Room 28 of
the Bel Harbour Motel.

From the Metroliner, at 110 miles per hour—an
impression of the New Jersey countryside, below. On a similar
trip, I sketched the baggage rack and the inside of the car. The
bright-red emergency stop handle was my grace note.

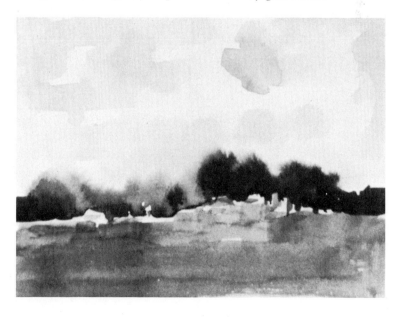

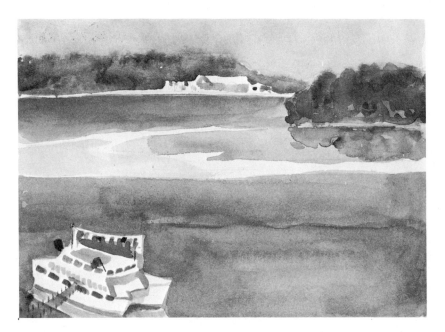

Above: A bend in the Ohio River, from Room 718 of the Executive Inn, Owensboro, Kentucky. I lectured here, for the opening of the National Academy Traveling Show at the Owensboro Museum of Fine Art. The near right-hand bank is Indiana.

Gravel barges, below, on the Ohio River. The traffic on this river never ceases to amaze me—I wonder how those "little" tugs can push twelve barges loaded with gravel.

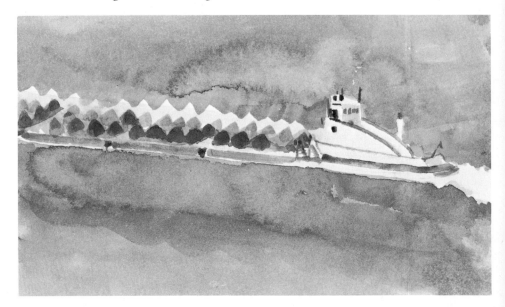

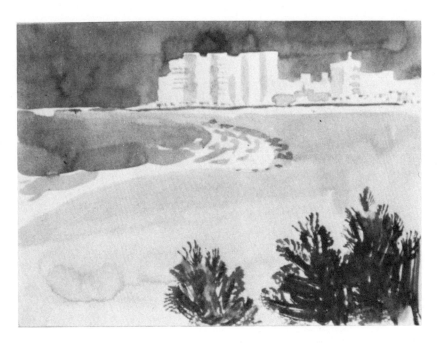

From Room 707 of the Sheraton Sand Key (above), Clearwater,
Florida, 1977. 8 AM on a brilliant morning. Below, boats on Biscayne
Bay, 1974. Notice the simplicity of the sky, a light band for the boats,
the dark sea. A common error in this type of sketch is to have all the
masts straight up and down. They should tilt as masts really do—with
the waves and tides.

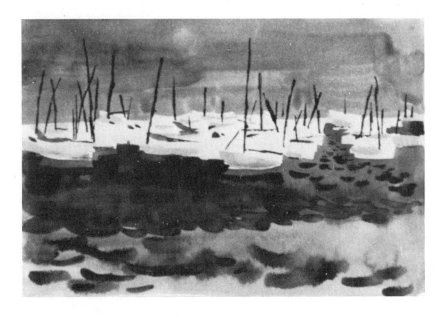

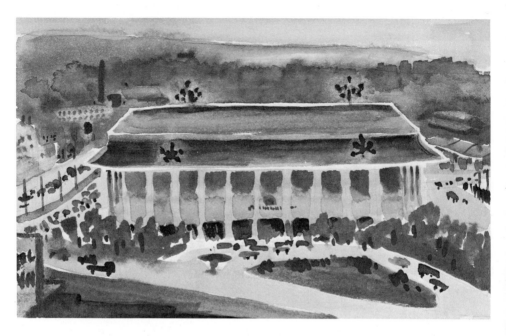

The Sports Stadium, Columbia, South Carolina (above), in 1978. As viewed from Suite 1421-23 of the Carolina Inn.
Below, the Capitol Building, Columbia, South Carolina.

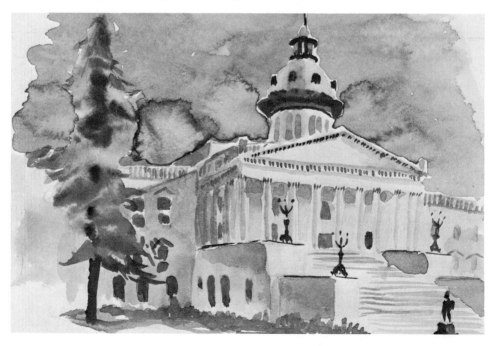

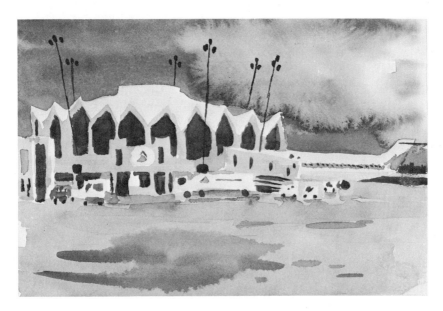

Delta Terminal at Indianapolis Airport, above. En route to New York, 1978.

Below, looking down from the balcony outside Room 606 of the Hyatt Regency in Indianapolis, March 3, 1978. Even though you may not be thrilled at sketching the lobby of a hotel, consider it to be like any other composition and see how interesting you can make it. Remember, you are learning as well as recording.

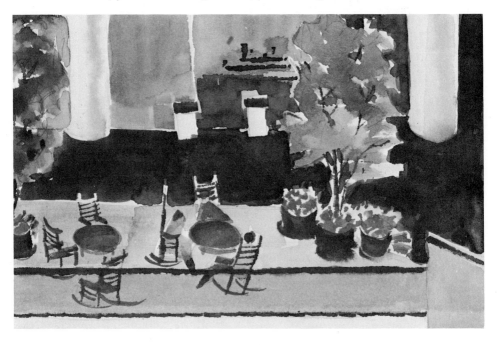

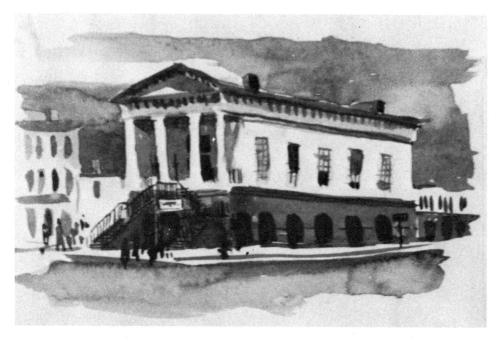

Old Market (above), Charleston, South Carolina. Below, the view from
Room 324 of the Holiday Inn at Meeting and Calhoun Streets,
Charleston, 1978. As you can see, this is more like a little picture than
a sketch, whereas the sketch of Biscayne Bay, done four years earlier,
is simpler.

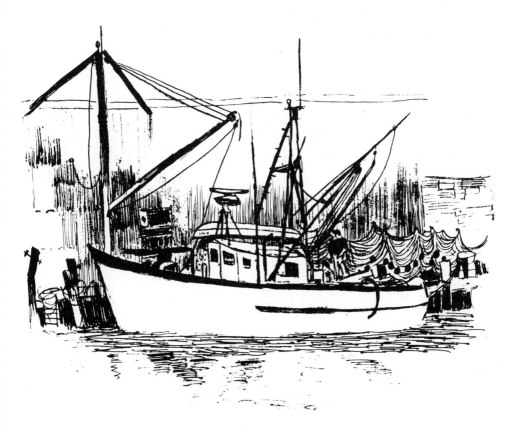

Above, pen-and-ink sketch of a trawler at the Portland, Maine, dock.
Pen-and-ink sketch of Pumpkin Knob (below), in Casco Bay, Maine.

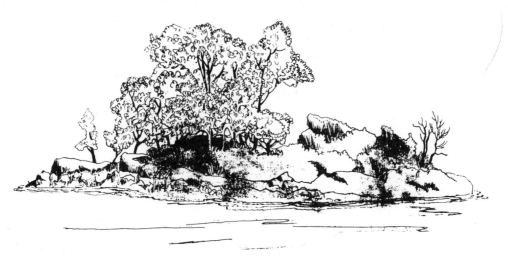

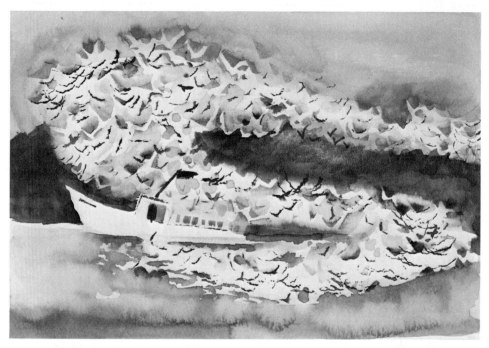

Returning lobster boat (above), at the entrance to Portland harbor, 1973. The lobsterman tossed unused bait overboard, and the gulls freeloaded.

Below, Ram Island Ledge Light, from Cape Elizabeth, Maine.

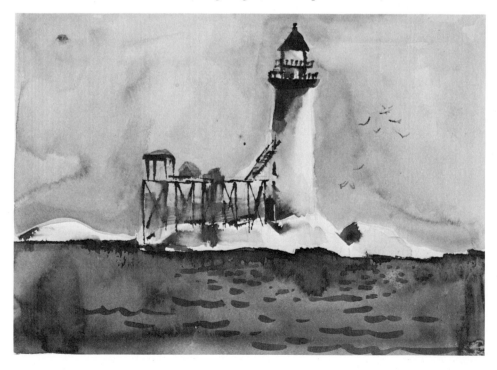

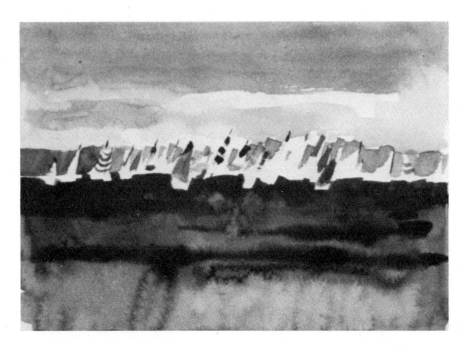

Peaks Island, Maine, August, 1974. Two versions of the start of the Monhegan Race as the yachts tacked through Hussey Sound on their way to the open Atlantic.

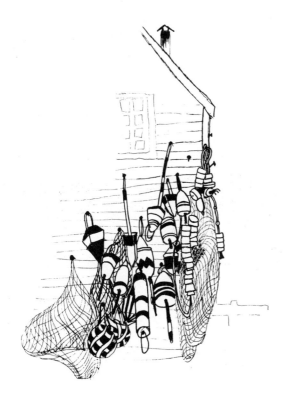

Lobster-pot markers, above,
on Monhegan Island, Maine,
1974. Pen and ink.
Below, old dock on
Peaks Island. Pen and ink.

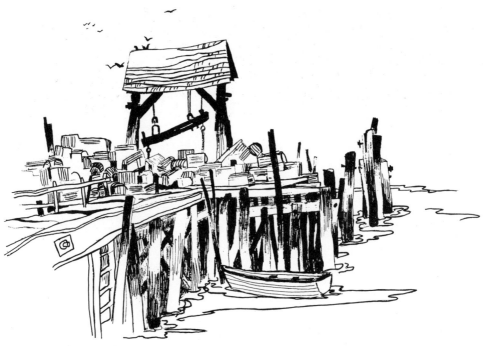

Pen and ink of Whaleback Rocks, on the ocean side of Peaks Island.
These rocks are part of an undulating strip of stone that runs all the
way along the coast of Maine. Every time it rose from the ocean, an
island was born.

In and Around Your Home

There are many places and subjects for sketching close to home, which in my case is New York City. You may not have skyscrapers and Central Park, but your sketchbook will teach you that there are subjects anywhere. You will learn to sketch things that at first may not appear to you to be appropriate. Often too much time is spent looking for the perfect vista when, as

Central Park, New York City.

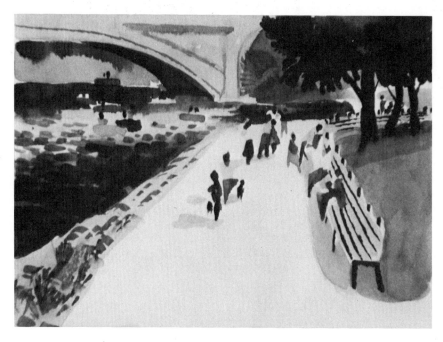

an artist, you should be able to take the most mundane scene and transform it.

You will learn to see more objectively—even a floating umbrella can be of interest. The umbrella on page 102 floated past our Central Park watercolor class for the entire afternoon. It reminded me of the movie *The Red Balloon,* for it danced past us on the surface, around the corner of the lake, back again, far out, and close in—and really displayed a personality of its own. Maybe it wanted to join the class, but I suspect it was asking to be sketched. So I happily obliged.

You started your sketchbook as a manual in which to practice translating some scene or vista that might seem very complicated at first into a readily discernible statement of what you saw or felt. By making many simple white, gray, and black sketches and using geometric shapes instead of literal ones, you became aware of pattern and design. Then you began to add color notes. With the repetition of these exercises, you should be able to progress rapidly to more complex scenes. Each will teach you something about the next, and you will also have the beginnings of a complete record of your progress.

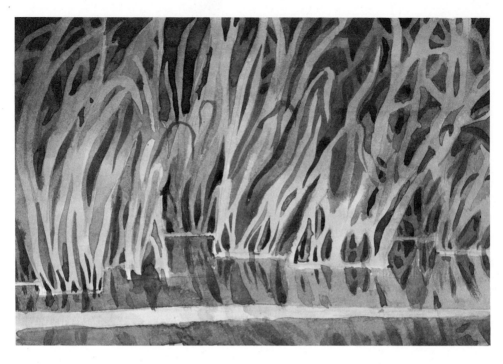

Above, "Dale's Reeds," Central Park, New York City. So named by me because they are a never-ending source of pleasure to me.
My friend, the umbrella, below. Central Park, 1981.

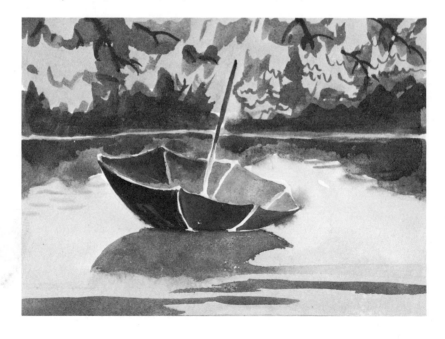

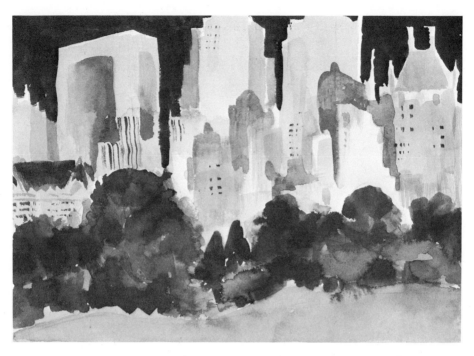

Cityscape of New York, above. Below, the Guggenheim Museum, on
Fifth Avenue, 1981.

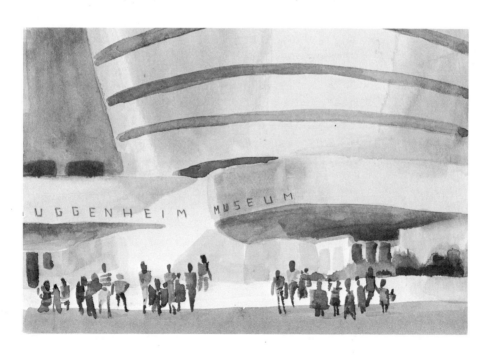

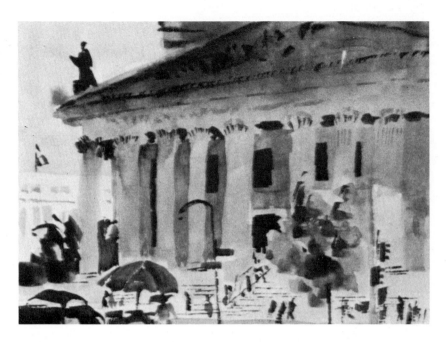

Above, New York State Supreme Court building, New York City, 1975. "The true administration of Justice is the firmest pillar of good government."

New York Stock Exchange, below. It was a chill November day in 1975.

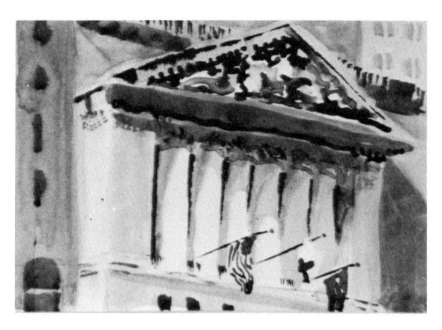

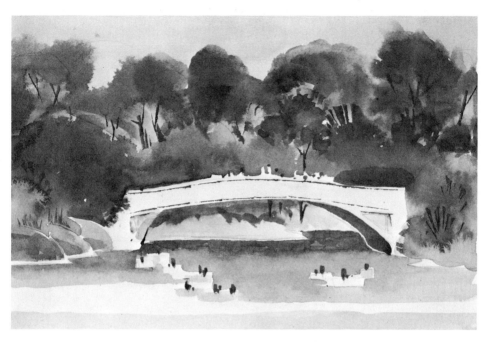

Above is a tonal sketch of Bow Bridge, Central Park, made in Winsor violet. You do not have to use only Payne's Gray for your tonal sketches; any color that will go from very dark to light will do.

Below, Mario demonstrating for the Central Park class.

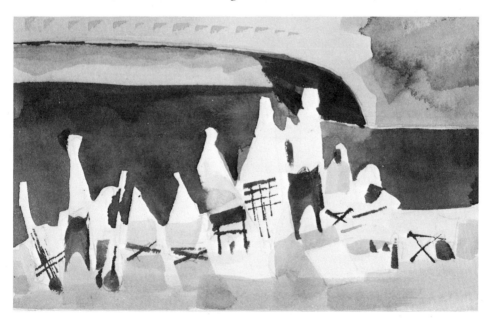

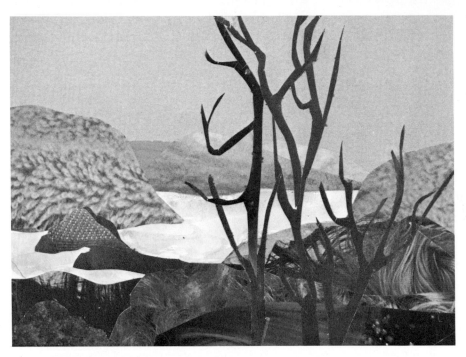

View of the Hudson River, from Garrison, New York, near West Point. This is a collage, not made on the spot but reconstructed from my quick watercolor sketch.

At the birth of my grandson Gordon, a family friend gave his mother and father a "special" bottle of wine with which to celebrate. After the appropriate and delicious ceremony, I made a copy of the labels for my sketchbook record. This wine, Romanée-Conti, is one of the world's truly great red wines. While none of us is an oenophile, we enjoyed it very much, for 1964 was a "Très Grande Année."

My copies of the labels, below. Gordon, we saved the real ones for you!

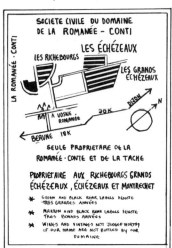

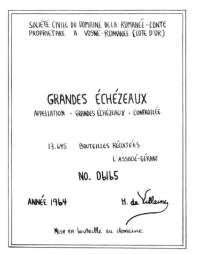

Quick pencil sketch of Gordon Cooper Eames Hellegers,
at four days old.

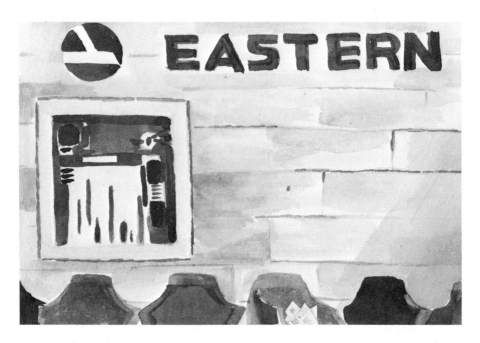

Above, waiting for Empire Airlines Flight 506 to the Adirondacks, August, 1979. Well, if you cannot see the runway or the airplanes, paint the fire hose!

Whispering Falls (below), Old Forge, New York.

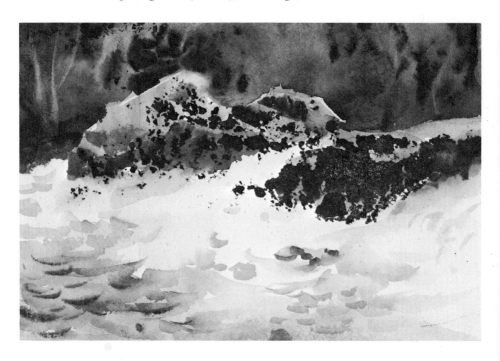

Art Deco in nature, above. I found some half-peeled bark on a yellow
birch, and these patterns showed up underneath. The entire tree is
covered with this type of design, in varying shades of tans and browns.
I had to restrain myself from peeling away more bark for fear of
hurting the tree.

Inside the woodshed at Covewood, near Old Forge, New York
(below). Pentel-pen sketch. My eye was caught by the circular saw
and the green-and-beige arrow design on the circular plywood behind
it. A bright red gasoline can made painting the scene irresistible.

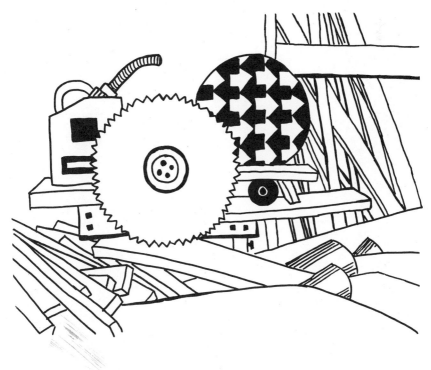

Little Moose Lake, from the Adirondack League Club, above. A misty, cool morning in 1979.

Below, boats at a dock on First Lake. We were surrounded by trees, and it took a few minutes to locate a subject. Then, all at once, there were a dozen subjects.

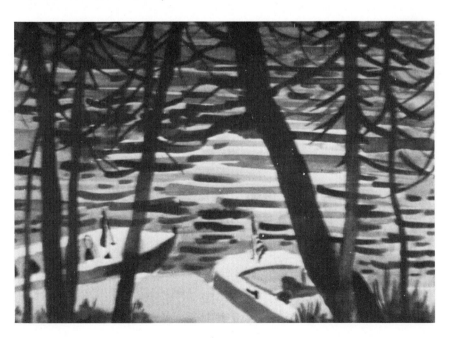

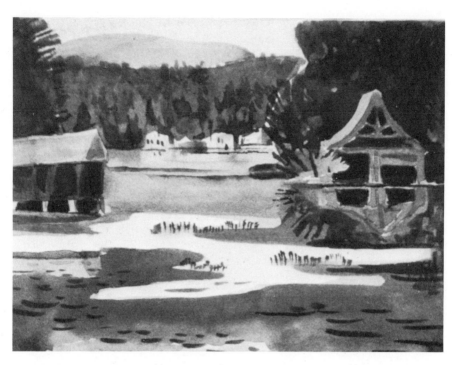

First Lake boathouses (above), Old Forge, New York. Below, Ski-Doo on Route 28, Old Forge, 1980. When I look at this sketch I remember the spot where I perched precariously by the side of the road as the cars whizzed by.

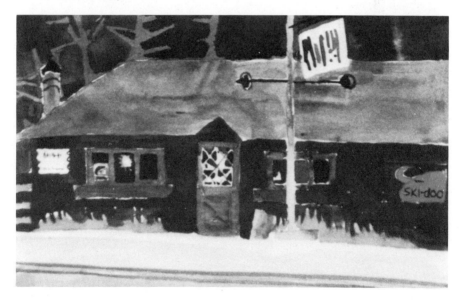

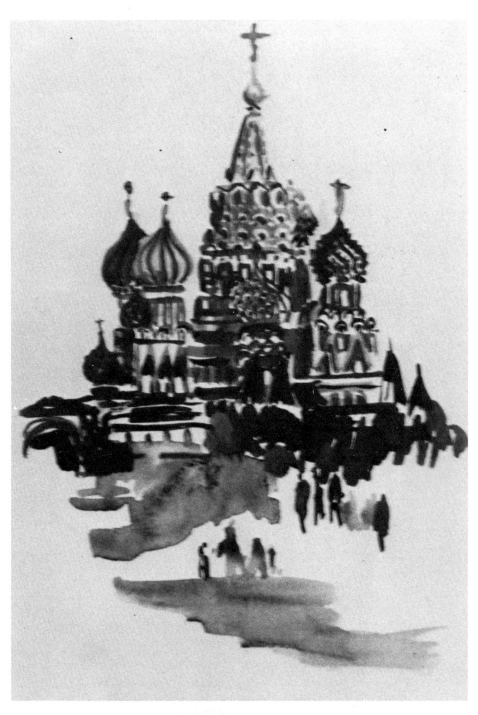

Saint Basil's Cathedral, in Moscow, Russia, August, 1974. A color
version of this sketch appears in the color section.

And Not So Close to Home

So far I have advocated sketching from around our country and home, as this is where we work and live—amidst more varied beauty per square mile than anywhere else in the world.

But now it is time to take advantage of all we've observed about sketching to make a journal of that trip to Spain, Jerusalem, or Japan. So let us complete our sketching tour with scenes from not so close to home, some far-off ports exotic and exciting to us because we don't live there. To the fruit seller on the Bangkok Klongs, the sight of 34th Street and Fifth Avenue would be equally exciting. The point is, look around you, learn to see the picture just in front of you.

I hope you have enjoyed our travels together. Don't forget that sketches can be made of anything, anywhere—like the wing tip of your plane as it flies over a cloud-covered Atlantic on the way home.

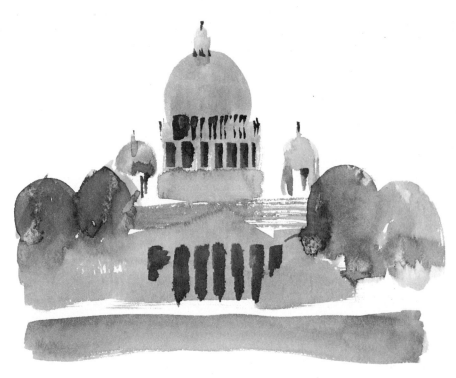

Saint Isaac's Cathedral, Leningrad, above. Below, Leningrad, August, 1974. In Russian *krasne* means *red* and it also means *beautiful*. However, the real color of Russia today is not their beloved red but a strong, sometimes dark, and always deeply penetrating gray.

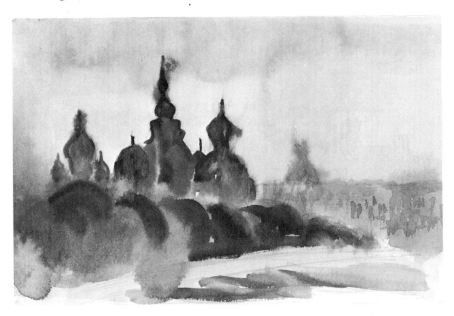

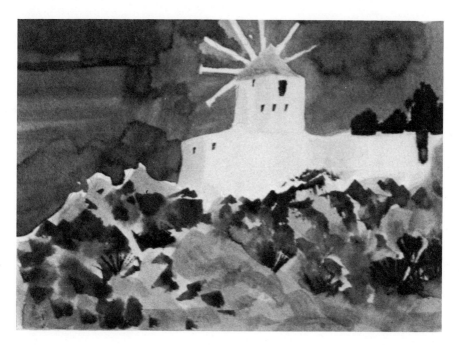

Island of Hydra, in the Aegean Sea, above. Just after I made this sketch we bumped into Robert Beverly Hale, the former Curator of American Art at New York's Metropolitan Museum, who was summering there.

Below, the Olive Tree of Athena and the Erechtheum with Caryatid colonnade atop the Parthenon, Athens, Greece.

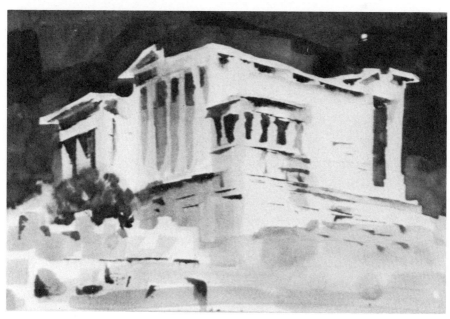

As I sketched, curious observers gathered. I have found that those who stop to watch are fascinated and very supportive of any efforts, no matter how you may be struggling. (Photo courtesy of Mario Cooper.)

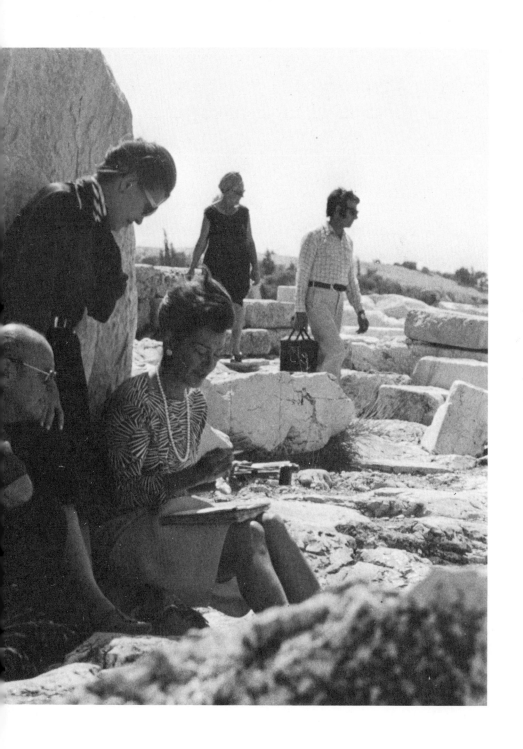

Harbor Master's Office (above), San Giorgio, Venice, Italy, in August, 1975. Below, a rubbing made of carvings by prisoners held in the Venice prison just over the Bridge of Sighs. It is from this famous bridge that the condemned had their last glimpse of the outside world and freedom.

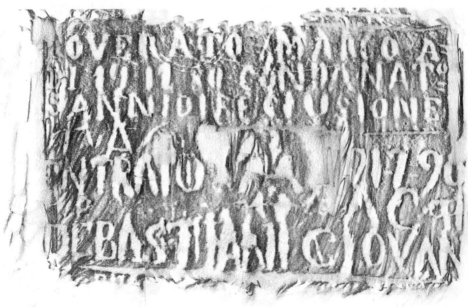

Above, Le Mont Saint Michel, on the French coast, 1981. Below,
cathedral in Milan, Italy, 1977.

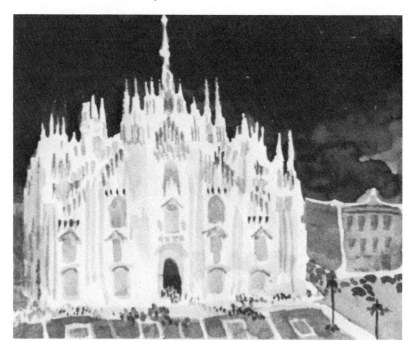

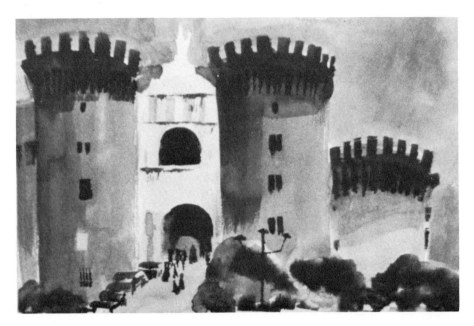

Castel Nuovo (above), Naples, 1974. I ran out of water, so this sketch was made with the help of beer.

Below, the view from Room 6 of the Capri Hotel, Isle of Capri. (See the color section.)

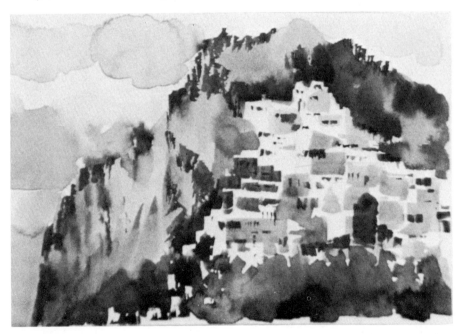

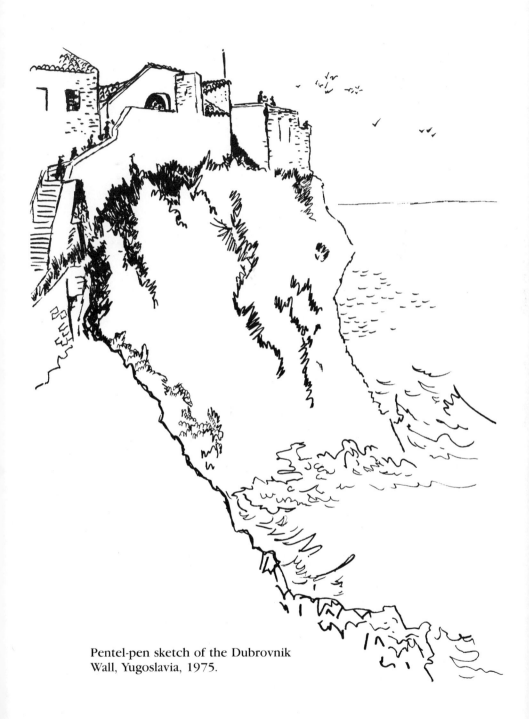

Pentel-pen sketch of the Dubrovnik
Wall, Yugoslavia, 1975.

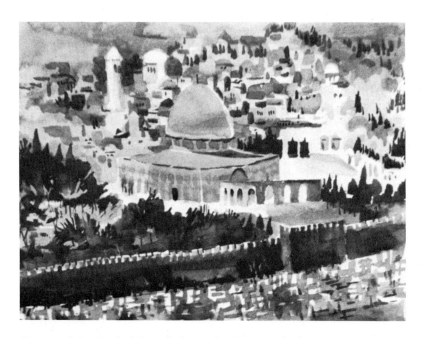

Dome of the Rock (above), from the Mount of Olives, Israel, 1977.
Below, Jerusalem impression. Sepia watercolor. (Both appear in the
color section.)

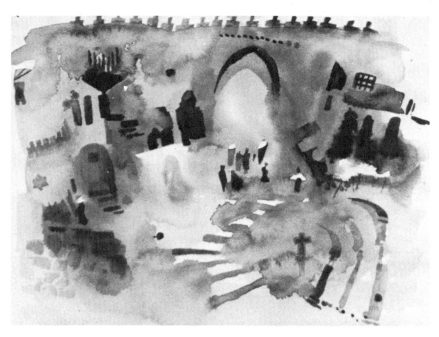

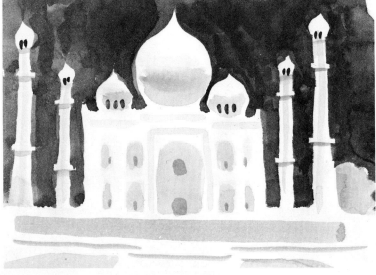

Left: Inside the Red Fort, Agra, India. Below: Taj Mahal, Agra, 1967.

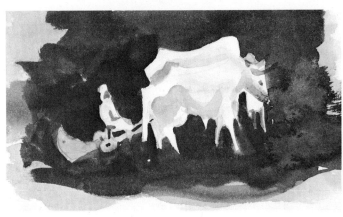

Mowing the lawn at the Taj. It seemed so odd to stand before such magnificence and see workers mow the lawn in this primitive fashion.

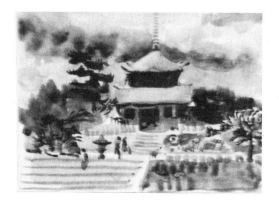

Left: Kiyumizu Temple, Kyoto, Japan, 1977. This is the first sketch I made after I had just left my half-full sketchbook in a taxi in Kyoto, and, not having the cab's number, I was never able to retrieve it.

As soon as we realized what had happened, Mario and I went searching for a paper-goods store. We found one, and Mario started to explain in somewhat limited Japanese what we were looking for. In perfect English, the proprietor directed us to a large rack holding every conceivable size of sketchbook. Mario said to the man, "If I were to ask for this in Japanese, what would I say?" The man replied, "Notobuko"—or, as we would say in America, "notebook."

Below, cormorant fishing at night, Kyoto, Japan, 1977. The blazing fire on the prow of the boat reflects off the fish in the water, allowing the birds to see and dive for them. A ring around the bird's neck prevents it from swallowing the fish (their craws can hold three to four fish), while a leash on each bird guarantees its return to the boat with cargo intact.

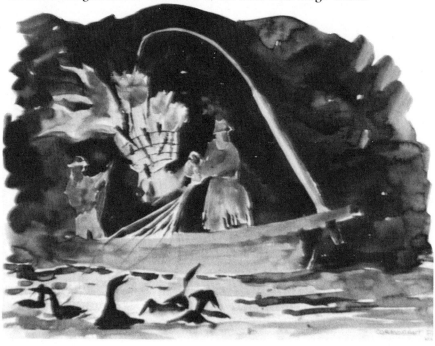

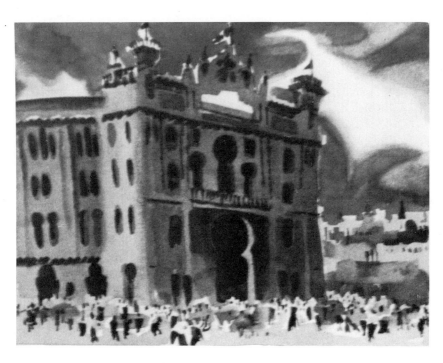

Plaza de Toros (above), Madrid, Spain, 1975. Below, Plaza Mayor, Madrid.

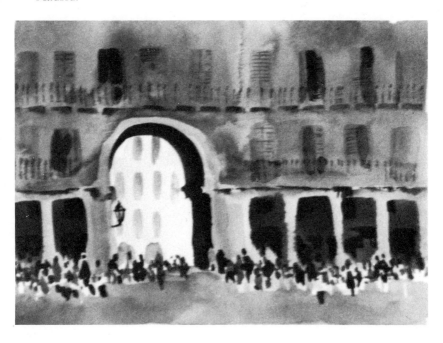

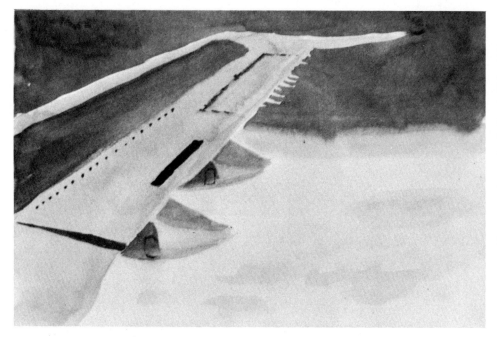

Above, TWA Flight 903. Winging over the Atlantic on our way home from Spain, 1977.

Pentel-pen sketch (below) of Hong Kong harbor, 1967.

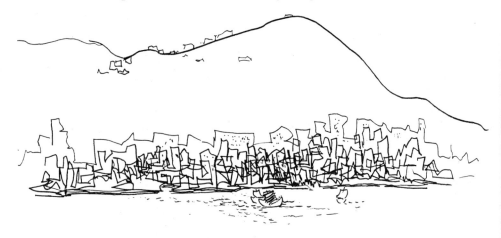

Index

abstraction, 27, 30, 31
airport sketches, 63, 64, 65, 67,
 68, 70, 73, 93, 108
Apollo 11, 47, 48, 51
Aquabee, 15
Art Students League, 31

collage, 17, 44, 83, 106
composition, 13, 20, 32
 pattern or design, 101
Cooke, H. Lester, 51
Cooper, Mario, 9, 105, 124

enthusiasm, 14, 21
Environmental Protection Agency,
 61

figure study, 34, 35, 36
flower study, 40, 41, 46, 80
 Proteas, 38, 39

geometric shapes, 19, 21, 32, 101
Grant, Gordon, 79

Hale, Robert Beverly Hale, 115
Hellegers, Gordon Cooper Eames,
 106, 107

Interstate 5
 California, 12, 72, 84
 Oregon, 82

materials, 13, 15, 16, 17, 18
Meier, Richard, 64
mood, 22, 36

NASA, 49, 51
National Aeronautics and Space
 Museum, 51
National Gallery of Art, 51

paintings
 Early Snow in the Siskiyous,
 60
 Firefly to the Moon, 51
 Hickory Revisited, 61
 Milkweed and Sunflowers, 61
 Proteas, 39
 Winter on the Rhine, 54
photographs, 9, 46, 11
 slides, 9, 11, 53, 54
progressive views
 Early Snow in the Siskiyous,
 60
 Winter on the Rhine, 53, 54
proverbs
 Burmese, 20
 Chinese, 32

rubbings, 12, 118

selection, 27
spirit, 31
 spontaneity, 15

tree study, 38, 46, 55, 56, 57, 58,
 59, 66

value
 tonal study—black, white, and
 gray, 11, 19, 20, 21, 24, 25,
 27, 28, 31, 32, 47, 101,
 105
 value scale, 22
vignettes, 13

Winsor & Newton, 15

zen, 9